Lian Quan Zhen

CHINESE
WATERCOLOR TECHNIQUES
for Exquisite Flowers

NORTH LIGHT BOOKS
CINCINNATI, OHIO
www.artistsnetwork.com

About the Author

Lian Quan Zhen is an award-winning artist and teacher of watercolor and Chinese painting, both nationally and abroad. He started sketching and painting during childhood and continued his hobby while practicing as a family physician in Canton Province, China. In 1985, Lian immigrated to the U.S. He received a bachelor of arts degree from the University of California at Berkeley in 1992 and a master of architecture degree from MIT (Massachusetts Institute of Technology) in 1996.

Lian has had many one-man shows in the U.S., Hong Kong and China and has developed an international following. His paintings hang in numerous institutional and private collections, including the MIT Museum. Besides holding many national and international workshops, Lian has taught summer painting classes for the University of California at Berkeley.

Lian has written two books for North Light Books: *Chinese Painting Techniques for Exquisite Watercolors* and *Chinese Watercolor Techniques: Painting Animals*. He was also a featured artist in several of North Light's Painter's Quick Reference series books.

Other fine North Light Books are available from your local bookstore, art supply store or visit our website at **www.fwmedia.com**

13 12 11 10 09 5 4 3 2 1

Distributed in Canada by Fraser Direct
100 Armstrong Avenue
Georgetown, ON, Canada L7G 5S4
Tel: (905) 877-4411

Distributed in the U.K. and Europe by David & Charles
Brunel House, Newton Abbot, Devon, TQ12 4PU, England
Tel: (+44) 1626 323200, Fax: (+44) 1626 323319
Email: postmaster@davidandcharles.co.uk

Distributed in Australia by Capricorn Link
P.O. Box 704, S. Windsor NSW, 2756 Australia
Tel: (02) 4577-3555

Library of Congress Cataloging in Publication Data
Zhen, Lian Quan
 Chinese watercolor techniques for exquisite flowers / by Lian Quan Zhen. -- 1st ed.
 p. cm.
 Includes index.
 ISBN 978-1-60061-088-2 (hardcover : alk. paper)
 1. Flowers in art. 2. Ink painting, Chinese--Technique. I. Title.
 ND2302.C6Z54 2009
 751.42'24343--dc22 2008024161

Edited by **Mary Burzlaff**
Designed by **Jennifer Hoffman**
Production coordinated by **Matt Wagner**

METRIC CONVERSION CHART

TO CONVERT	TO	MULTIPLY BY
Inches	Centimeters	2.54
Centimeters	Inches	0.4
Feet	Centimeters	30.5
Centimeters	Feet	0.03
Yards	Meters	0.9
Meters	Yards	1.1

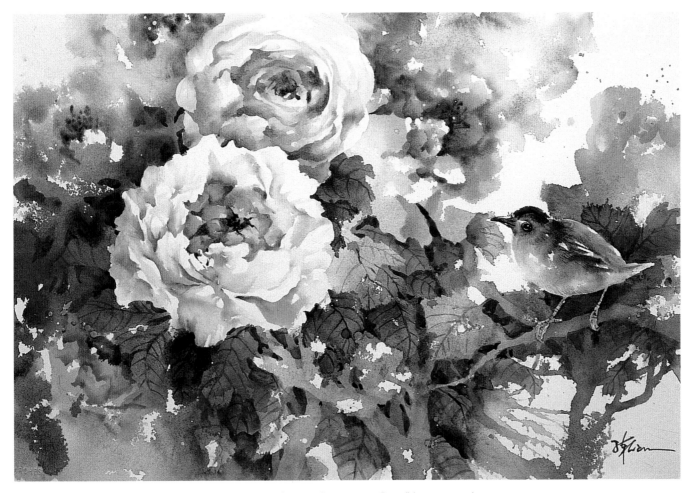

PEONY *watercolor on Arches 140-lb. (300gsm) cold-pressed watercolor paper 14″ × 21″ (36cm × 53cm)*

Acknowledgments

Many thanks to my wife, Yiling Zhen (Bei Zhang), my closest friend. Thanks also to my mother- and father-in-law, Yuenan Zu and Zhenfu Zhang, for their encouragement and their efforts in taking care of my little son Arnold so that I could focus on writing.

Also, many thanks to the following friends who have helped me tremendously in my art career: Beverley Letard, Carole Gum, De Law-Smith, Debra Ann Prater Ashton, Dianna Bickford, Ellen T. Harris, Gail Racy, Grace Clark, Imogene Dewey, Ingram Vernon, Irene Pearson, Joyce and Roger Ramadom, Joyce Estes, Karin Payson, Laurie Tenpas, Marjorie Haggin, Mary Wong and Ray Steele, Nancy Melton, Nancy and Bob Terrebonne, Nancy Thompson (I miss her), Pamela Lowell, Ray Fugatt, Sharon Digiulio, Shirley Wright, Sim Van De Ryn, and Sue and John Clanton.

My thanks also to Jamie Markle for making this book possible through North Light Books. Thanks also to Mary Burzlaff, my editor, who helped make my writing clear and easy to understand, and to everyone else at North Light Books who helped put this book together.

Finally, I thank my art collectors. Without your support, I couldn't be a full-time artist, which is my life's dream.

Dedication

To my wife, Yiling Zhen (Bei Zhang), who is a wonderful artist yet sacrifices her art career for mine and for our son Arnold. To my mother, who I wish could have lived to see my other two books and this one in publication. She is always there encouraging and cheering for me!

TABLE OF CONTENTS

Introduction 9

Development of Chinese Floral Painting 10

Three Styles of Floral Painting 11

Two Methods for Painting Flowers 12

Chinese vs. Traditional Western Painting 13

Index 126

1 MATERIALS & BASIC TECHNIQUES

page 14

❋ Chinese Painting Materials

❋ Using Chinese Brushes

❋ Watercolor Materials and Techniques

❋ Negative Painting

❋ Stretching a Chinese Painting

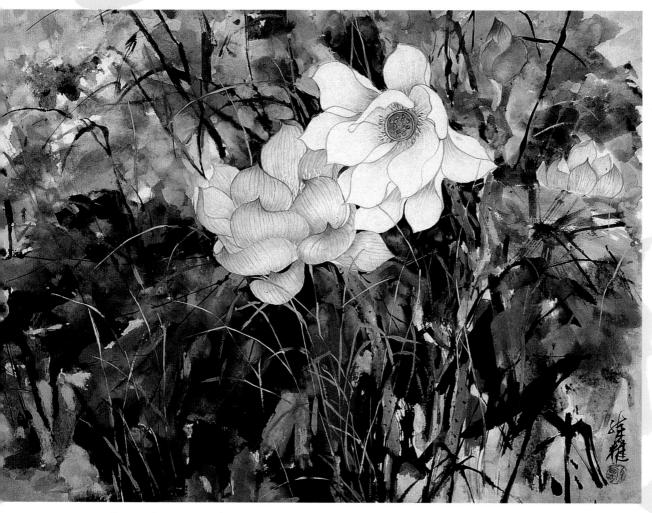

LOTUS *Chinese color on mature Shuan paper 14" × 18" (36cm × 46cm)*

2 SECRETS OF CHINESE PAINTING COMPOSITION

page 28

✿ Focal Points

✿ Seven Principles of Contrast

✿ Balance

✿ Three-Line Integration

✿ Geometric Organization

✿ Dynamic Movement

✿ Leaving White Space

✿ Composition Methods in Action

3 DEMONSTRATIONS

page 42

✿ Iris

✿ Lotus

✿ Magnolia*

✿ Peony*

✿ Orchid*

✿ Coconut Tree

✿ Banana Tree

✿ Rose*

✿ Water Lily*

✿ Tomato*

✿ Grapes*

✿ Hollyhocks*

✿ Chrysanthemum

ORCHID *watercolor on Arches 140-lb. (300gsm) cold-pressed watercolor paper 21″ × 14″ (53cm × 36cm)*

4 EXPERIMENTAL CHINESE PAINTING TECHNIQUES

page 110

✿ Printing With Glass—Wisteria

✿ Using Glue as a Resist—Cactus

✿ Crinkling Rice Paper—Orchids

✿ Painting on Primed Canvas—Poppies

** Includes step-by-step instructions for both traditional Chinese and Western Watercolor Techniques*

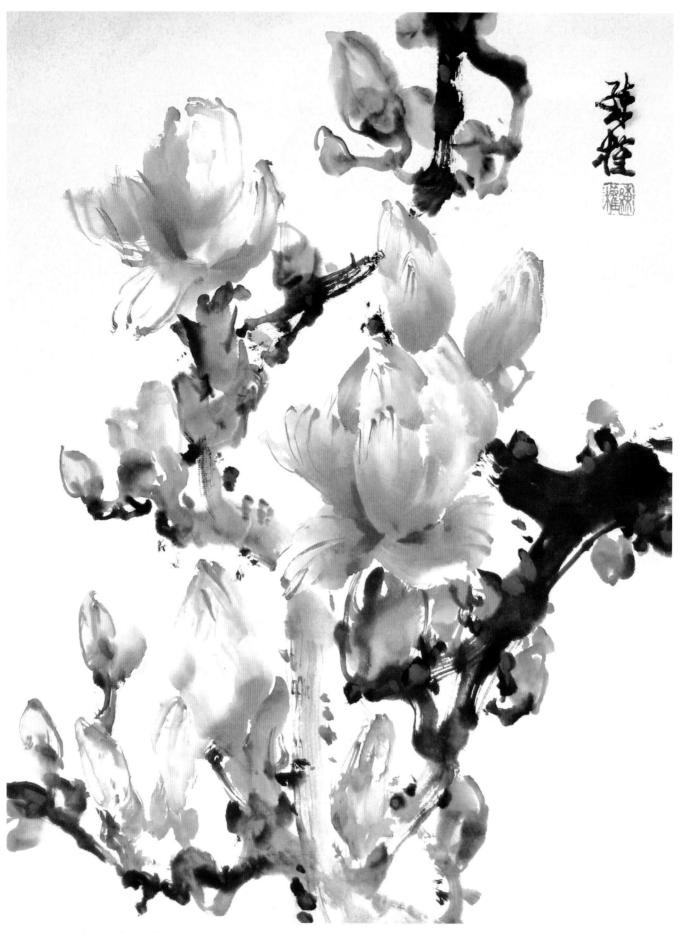

MAGNOLIA *Chinese ink and color on raw Shuan paper 21" × 16" (53cm × 41cm)*

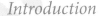

Introduction

Flowers are a popular subject in Chinese and watercolor painting. This book is intended to provide basic instructions on how to paint them successfully. I will explain theories and techniques from both Eastern and Western art as simply as possible, with diagrams, sketches and step-by-step demonstrations. I developed these lessons with both the beginning and professional artist in mind.

For years, I've studied with both Chinese painting and watercolor masters and have attempted to blend Eastern and Western art theories and techniques in my own work. The results of these integrations are intriguing and sometimes even amusing. Many of the paintings you'll see in this book are difficult to identify as either Chinese or watercolor. The difference is not important to me as long as they capture the essence of the flowers.

Few Chinese paintings in this book were created in a strictly traditional manner, though I do demonstrate ancient Chinese theories and basic techniques. Hundreds of years ago, a famous Chinese painting master said, "Brush and ink should follow the change of time." I take his word seriously in my art creation endeavors. As a result, my paintings have developed some distinctive characteristics. Specifically, the Chinese paintings are full of vibrant colors (which is more typical of Western painting) and the watercolor paintings have evocative white space (which is more typical of Chinese painting).

I have loved painting since I was a little boy, but I never expected to become a full-time artist. My breakthrough came in the early 1990s, after I had been living in the U.S. for nearly ten years. I think I achieved my dream because I was able to observe and learn from many masters and techniques that were not available in China when I lived there. More importantly, I gave myself a lot of freedom in painting. I didn't want to simply copy objects or rely on one master's methods. Sometimes I joke with my students in the U.S., saying that Chinese artists paint freely because they seek the freedom that rarely exists in their traditional society. By contrast, some American artists paint too tightly, perhaps because they enjoy so *much* freedom in their lives.

Painting should be a happy experience, not a pressured activity. No artist can paint a masterpiece every time he paints. Relax and follow the steps of my painting process. You can learn a lot, have fun and be happy.

—*Lian Quan Zhen*

Foreword

Since 2002 we've had the pleasure of hosting Lian Zhen annually as an art workshop instructor. His painting style, coupled with his knowledge of the traditional painting techniques of the East and the watercolor techniques and perspective theory of the West, has made him one of our favorite instructors. Lian's talent as a master artist inspires people from all over the world to attend his workshops. An enthusiastic instructor and effective communicator, he helps his students achieve their own unique style using his Chinese brush painting techniques and his watercolor pouring and blending methods. Lian's instruction on design composition and color will strengthen your skills and help you become a better artist. Enjoy this book as Lian takes you step by step through painting flowers!

—*Debra Ann Prater Ashton*
 Art Workshop Coordinator
 Art In The Mountains, Bend, Oregon

DEVELOPMENT OF CHINESE FLORAL PAINTING

Chinese floral paintings usually include birds, insects and small animals in the compositions. They are called floral-bird paintings, one of the three main categories of Chinese painting. The remaining two are figure and landscape. Floral-bird painting developed later than the figure and landscape categories. When figure and landscape paintings reached their golden age in the Tang Dynasty (618–907 A.D.), floral-bird paintings were just emerging.

Floral-bird paintings first appeared in the Tang court, which employed famous artists to paint the palace's daily life. Artist Huang Chuan created colorful, detailed paintings from the collections of rare species of birds, animals and beautiful flowers enjoyed by the royal family. Later, Huang Chuan's offspring and students continued his magnificent works during the Sung Dynasty (960–1280 A.D.). Their painting style, called court painting, was vivid in color and highly detailed. This marked the beginning of detail-style painting.

During the latter part of the Sung Dynasty, artist Hsu Hsi developed a new technique for floral-bird paintings. He was an official who traveled extensively, which allowed him to explore a variety of flowers and birds in nature. He painted them with fewer colors and less detail than the detail-style artists did, emphasizing instead the brushstrokes and use of ink. Many artists followed this less meticulous way of painting, which marked the emergence of spontaneous-style painting.

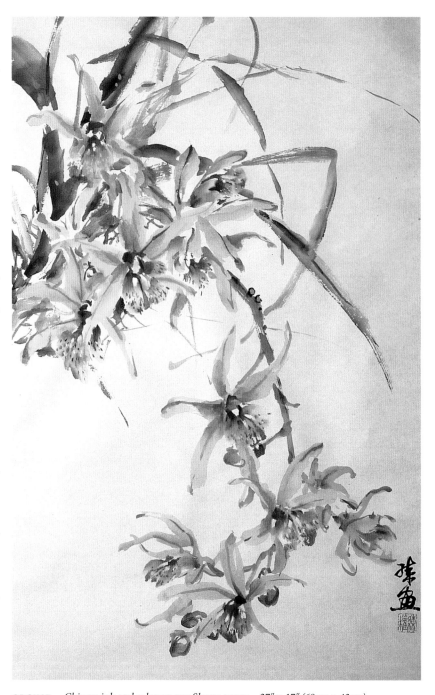

ORCHID *Chinese ink and color on raw Shuan paper* *27" × 17" (69cm × 43cm)*

THREE STYLES OF FLORAL PAINTING

Over the centuries, floral-bird paintings have evolved into three main styles: detail style, spontaneous style and a third style that combines elements of the first two styles.

A detail-style painting depicts objects in detail with vivid colors (see *Iris* on this page). To paint in this style, start by using ink and a small brush to outline the objects on mature Shuan paper. Then call out the shapes with a variety of ink tones. After the ink dries, apply layers of color until the color reaches the desired saturation and value (the ink-toning step can be omitted in some cases). For a detail-style demonstration, see the Iris step-by-step on page 44.

Spontaneous style is the most common style of Chinese painting. It emphasizes capturing the essence but not the appearance of the subject. "Simple is beautiful." "Less is more." "Paint what you want to see but not what you see." These ideas express the essence of this style. *Fall Breeze on a Lotus Pond* is a typical spontaneous-style painting. I painted it with minimum strokes and few colors, but you can feel the breeze, see the movement of the leaves and grasses and hear the songs of the birds. There are many demonstrations in chapter three that will allow you to explore these techniques further.

In the combined half–detail—half–spontaneous style, some objects are painted with detail while others are created spontaneously. This doesn't mean dividing the objects into two equal groups, one painted in detail and the other spontaneously. In general, the focal-point objects are detailed and the others are loose. For example, the frogs in *Water Lily and Frogs* have a lot of details while the water lily and other objects are merely suggested. To enhance your understanding of this style, see the Lotus demonstration on page 48.

WATER LILY AND FROGS
Chinese ink and color on mature Shuan paper 26" × 18" (66cm × 46cm)

FALL BREEZE ON A LOTUS POND
Chinese ink and colors on single-layer raw Shuan paper 26" × 26" (66cm × 66cm)

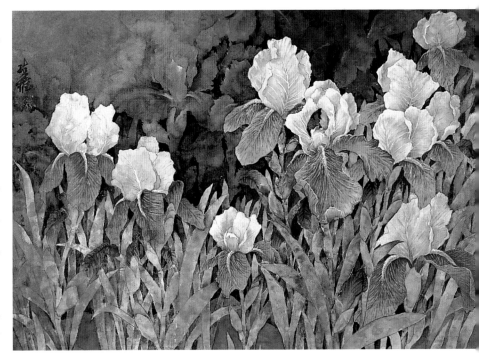

IRIS *Chinese ink and color on mature Shuan paper 16" × 23" (41cm × 58cm)*

TWO METHODS FOR PAINTING FLOWERS

There are many ways to depict flowers in Chinese painting, but most fall into two primary methods: bone and no-bone. The bone method starts with outlining the flowers and then filling in colors. The outlines are referred to as the "bones." The no-bone method, on the other hand, starts without an outline or a sketch.

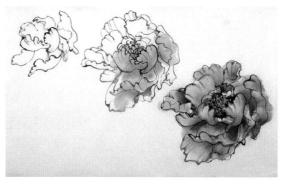

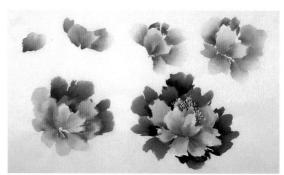

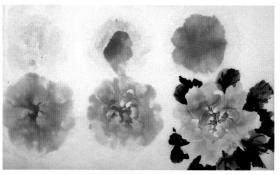

Bone Method

Here's a peony painted in three steps: First, I outlined the flower with ink. Then, after the ink dried, I painted each petal with color. Finally, I added darker colors to the petal bases to further define their shapes. The bone method is commonly implemented in painting detail flowers.

No-Bone Method

These peonies were painted using the no-bone method. In each image you can see six steps (from left to right, upper row to lower row). The peonies were neither outlined nor sketched prior to my applying the color. On the top, I created each petal with one stroke. On the bottom, the base colors of the flower were applied first, and then I defined the petals with white pigment. The no-bone method is widely used in spontaneous-style paintings.

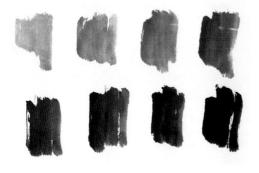

Water-Ink Painting

Some spontaneous-style paintings are created with ink alone. They are called *shui-mo hua* (water-ink painting) in China and *sumi-e* in Japan. Ink is a main pigment in Chinese painting, and water-ink painting takes advantage of its variety of tones and textures. Above you can see eight different tones on raw Shuan paper. Chinese ink is very dark. The more water you add, the lighter is becomes. You can dilute the ink to create many tones. Take a little ink and experiment (you can use any kind of ink). On the right is a typical water-ink-painting.

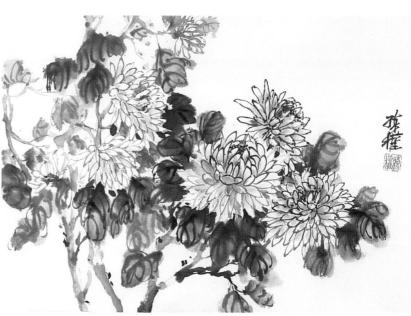

CHRYSANTHEMUM *Chinese ink on single-layer raw Shuan paper* 14" × 20" (36cm × 51cm)

CHINESE VS. TRADITIONAL WESTERN PAINTING

Differences

Besides differences in medium, Chinese painting uses strokes to define objects, while Western painting relies on surfaces, lights and shadows to render objects. Also, Chinese painting uses the power of suggestion to capture the essence of objects, while traditional Western painting relies on the meticulous depiction of the objects' forms.

Similarities

With the emergence of Impressionism, many Western paintings moved away from strict representation to impression. This is close to the Chinese method of capturing the essence of objects.

Another similarity between Chinese painting and modern Western painting is the harmonious use of color. Every painting tends to have a dominant color.

Even though I use Chinese painting materials to paint Chinese paintings and watercolor materials to paint watercolors, people sometimes can't easily identify my paintings as Chinese or watercolor. This is because I integrate the theories and the techniques of each style, and focus on capturing the life of the objects. This frees and encourages me to create paintings that are different from those of other artists.

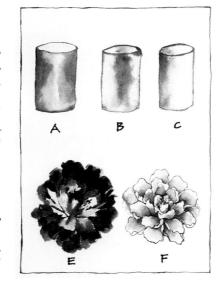

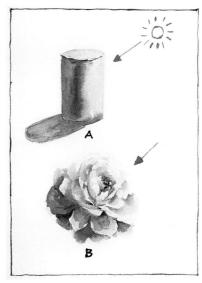

Differences

On the right is the Western method of depicting objects: The cylinder and peony are rendered according to the light source with highlights, darkest areas, reflections and shadows. The image on the left shows the Chinese painting method: Regardless of the light source, the cylinders and flowers are depicted without highlights, reflections or shadows, yet they still have a 3-D effect. It's interesting to note that in painting night scenes, Chinese artists do not paint dark colors. Instead, a moon in the sky or a lamp lit on a table indicates that it is night, while the rest of the painting is rendered as if it were a bright day.

Similarities (below)

Compare these water lily paintings, which illustrate the merging of the East and West. On the left is a spontaneous-style Chinese painting. On the right is an impressionistic painting by my wife, Yiling. The Chinese painting has minimum strokes and the objects are simplified. Likewise, the oil painting ignores many details in attempt to capture the spirit of the flowers.

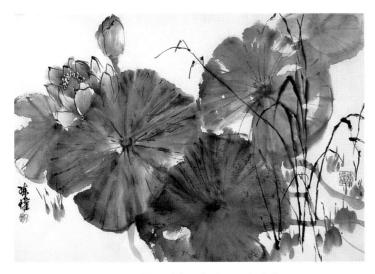

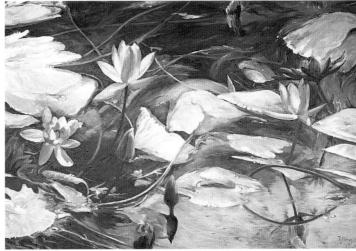

WATER LILY *Chinese ink and color on single-layer raw Shuan paper 16" × 20" (41cm × 51cm)*

WATER LILY BY YILING ZHEN *oil on canvas 24" × 36" (61cm × 91cm)*

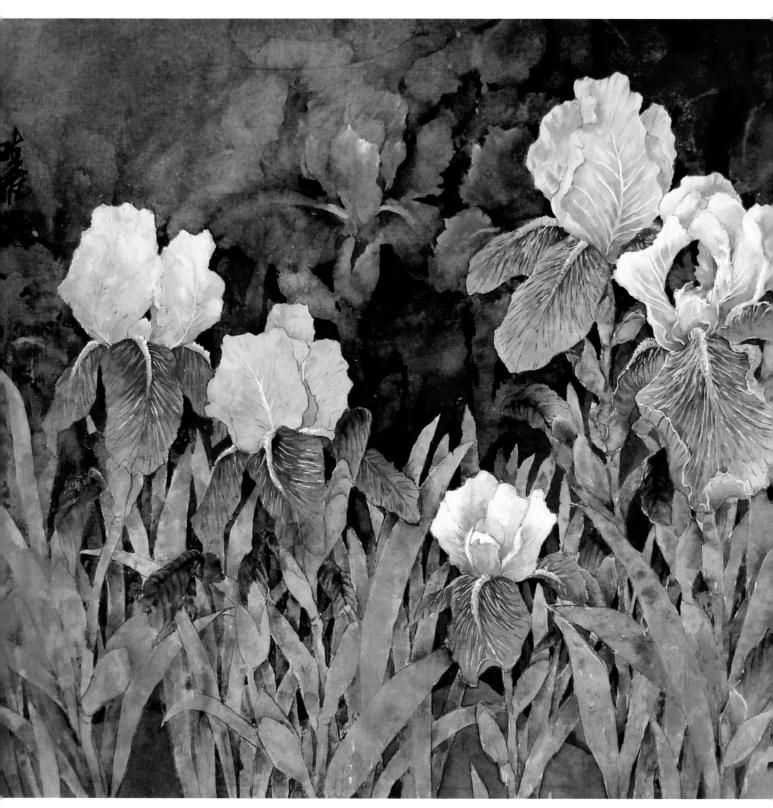

IRIS *Chinese color on mature Shuan paper 16″ × 23″ (41cm × 58cm)*

1 MATERIALS
& BASIC TECHNIQUES

To learn Chinese painting you need only a few materials: ink, Shuan paper (rice paper), a Chinese brush, Chinese color and a mat. Eventually, you may want to purchase a chop, a stamp carved on soapstone for sealing the painting. You do not need fancy and expensive materials when you are just starting out. I strongly believe that a great painting comes from the artist's brain and hands rather than from exotic materials.

CHINESE PAINTING MATERIALS

Some art supply stores carry small Chinese painting kits that contain tiny brushes, ink stones, ink sticks, chops, rouges and water containers. These are very economical, but the materials they include are low quality. They are designed for children to play with or for display. While I recommend buying quality supplies, I don't encourage spending a lot of money on supplies. However, in general, you get what you pay for.

Color

Chinese painting color is less transparent than watercolor but less opaque than gouache. This paint is made with strong binding glue, so it doesn't blend as dramatically as watercolor; the paint adheres firmly to Shuan paper. After a Chinese painting is finished, it needs to be stretched to bring up the colors. Many Shuan papers are semitransparent and the colors bleed through the surface. During stretching, a second layer of Shuan is pasted on the back of the painting. This additional layer makes the colors more visible. The stretching process also removes the wrinkles in the Shuan paper. During the stretching process the painting is wetted, but the Chinese painting colors don't bleed (for more on stretching see page 26).

Many Chinese painting colors are made by Marie's, a famous brand in China comparable to Winsor & Newton in the United Kingdom. Keep in mind that Marie's also makes watercolor and oil paints. Sometimes my students accidentally buy Marie's watercolor, thinking that Marie's produces only Chinese painting colors. Read the label on the box carefully to make sure you're buying the right product. It should be clearly marked "Chinese Painting Color."

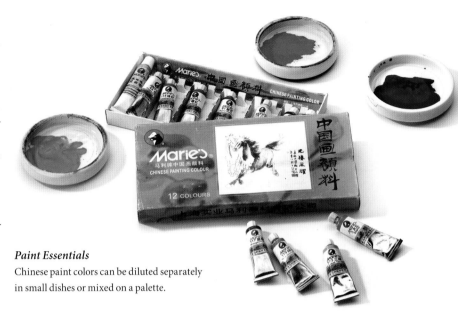

Paint Essentials
Chinese paint colors can be diluted separately in small dishes or mixed on a palette.

Ink

Traditionally, Chinese artists have made ink by grinding ink sticks on an ink stone with water. In recent years, high-quality bottled ink has become available. It doesn't require preparation (thus, you don't need an ink stone or ink sticks) and is easy to transport. In fact, I use bottled ink most of the time, including in all the Chinese painting demonstrations in this book. Similar to Chinese painting colors, the ink is made with strong glue. Once it dries on Shuan paper, it will remain there until the paper is destroyed. When diluted with water it becomes a nice gray tone like graphite. Japanese sumi ink is similar to Chinese ink, and you can use it to paint Chinese paintings. However, do not use other inks (such as fountain pen ink) to paint on Shuan paper, because they will bleed during the stretching process.

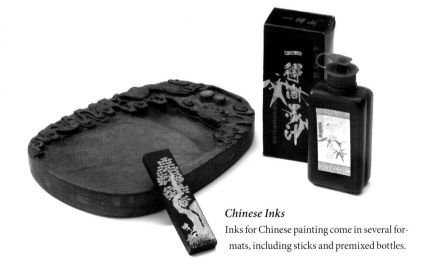

Chinese Inks
Inks for Chinese painting come in several formats, including sticks and premixed bottles.

Brushes

Unlike watercolor brushes, Chinese brushes don't have a numeric sizing system. Some brushes are as big as a broom, while others have only one hair.

Chinese brushes come in three textures: soft, medium and hard. Those made from sheep and rabbit hairs are white in color and soft in texture. Use this type of brush for painting soft objects like flowers. Brushes made from wolf, ox and horse hairs are brown or black in color and hard in texture. Use these brushes to paint rough objects such as rocks and trees. The medium-texture brushes are made from a combination of soft and hard hairs. These brushes can be used for painting a variety of textures. To start, you need both soft and hard brushes in sizes ranging from small to large.

What makes a good Chinese brush? First, the hairs of the brush should be firmly attached to its handle. Every Chinese brush loses its hairs, but a good one loses hairs at a slow rate and lasts a long time. A good brush will retain most of its hairs after hundreds of uses, while a poorly made brush might lose most of its hairs after being used only a few times. Second, when the hairs are open (see the instruction on how to open a Chinese brush on page 19) and soaked with water, they should come together, forming a point at the tip. The price of a high-quality Chinese brush is similar to that of a well-made watercolor brush.

Paper

Shuan paper (rice paper) is made from Shuan grasses grown in mideastern China. Two kinds of Shuan papers are commonly used for painting: Raw (non-sized) is used for spontaneous-style paintings, and mature (sized) is used for detail-style and half–detail—half–spontaneous style paintings.

Raw Shuan paper has strong absorption and blending capabilities, similar to a paper towel. It comes in double-layer and single-layer sheets. The double layer is thicker and more absorbent, but allows for less blending, while the single layer is thinner, less absorbent and allows for more blending.

Mature Shaun paper is thin and sized with alum on both sides. It is somewhat like hot-pressed watercolor paper. It allows a little blending, but it isn't absorbent. Some mature Shaun paper is sparkly on one side; this is the side for painting. Other mature Shaun papers do not have sparkles, and either side can be used for painting.

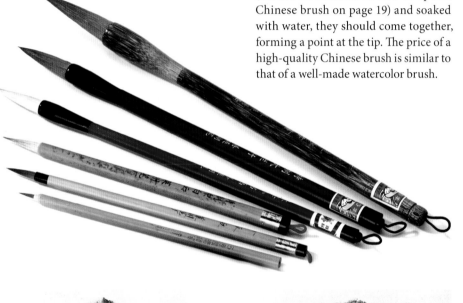

My Brushes of Choice

These brushes are the sizes I use most commonly in paintings. The rule of thumb in choosing a brush: The larger the strokes, the bigger the brush, and vice versa.

Raw Shuan Effects

Raw Shuan paper creates unique effects. At the top left you can see the bleeding that occurs at the edge of strokes. On the top right are overlapping strokes separated by watermarks. At the bottom left you can see the effect of adding intense ink on top of medium-toned ink. On the bottom right is the texture of ink strokes painted over a wet area.

There are several reasons why you shouldn't sketch on raw Shuan paper before painting in the spontaneous style:

1 Most Chinese-style artists have practiced painting the same subjects over and over again, hundreds of times, to the point that "Bamboo grows in one's soul."

2 You can organize the composition in your mind rather than on the paper.

3 You will be able to change the composition by following the flow of the painting process.

4 Raw Shuan paper is fragile, and sketching can break it very easily.

If you must sketch on the raw Shuan paper before painting, do so lightly with charcoal. Then use a dry flat brush to shake the excess charcoal from the paper.

Like raw Shuan paper, mature Shuan paper is easy to break. When using it to paint in the detail style and/or the half–detail—half–spontaneous style, do the sketches on tracing paper, then trace the images onto the mature Shuan paper with a small brush and medium-toned ink. You can see this method in the *Iris* and *Lotus* painting demonstrations in chapter three (pages 42 and 46).

Chop

Chops are carved stamps commonly made from soapstone. Every Chinese artist has a name chop. Many also have "leisure chops," which are carved with whatever words or expressions the artist likes, such as "peace," "lucky," "love," "less is more" or "no free lunch." Every finished painting should have a name chop as a seal, below the artist's name. In some cases, more than one chop should be used. Sometimes an additional chop is used to balance the composition. For example, if one corner of a painting is too empty, and the artist does not want to add more objects to it, a chop can be applied there instead. Another reason to use a chop is to show the dramatic contrast between the red color of the chop (or chops) and the black ink on the painting, especially in a water-ink painting (see the Chinese painting *Chrysanthemum* painted in water-ink style on page 12).

Chinese Painting Tools
Traditional Chinese painting materials include chops, rouges, wood weights and felt mats.

Mat

I typically create Chinese paintings on a flat surface covered by a felt mat that provides a soft, absorbent surface for the Shuan paper. Light-gray fabric, about 1/8-inch (3mm) thick, works well for the mat. Many Shuan papers are semitransparent, so don't use black or intensely colored fabrics. If you do, the mat's color will deceive your eyes and cause color confusion in your painting.

Paper Weights

Place paper weights on the edges of the paper to keep it flat and easy to paint on. I use long, wooden weights.

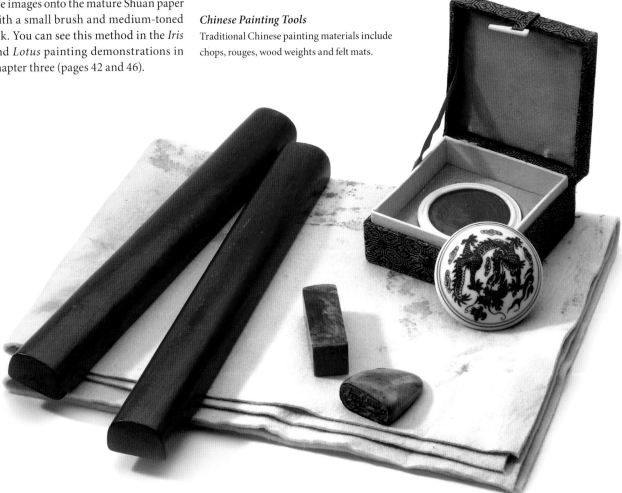

USING CHINESE BRUSHES

Opening and Cleaning

A newly purchased brush has firm hairs glued together and covered by a plastic cap. Unbind the hairs before using the brush by leaving the hair portion of the brush in water for several minutes (up to an hour). The glue will dissolve and the hair will loosen up so you can use the brush for painting. After painting, rinse the hair with water (soap isn't necessary). Don't put the cap back on the brush because it will keep the hair wet, and the moisture will damage the brush.

Holding the Brush

To hold the brush, use your index finger and thumb to grip the middle of the handle, then close the other three fingers loosely to reinforce the grip (see images at right).

Do not hold the brush as you would a pencil or pen. You won't be able to manipulate the brush to create beautiful strokes. Holding the brush sideways to paint is called "side brush" (see bottom left).

Another common way to hold the brush is straight from the surface of the Shuan paper. It is called "center brush" (see bottom right).

Controlling the Brush

The amount of water, ink and color in a brush affects the stroke textures and the way the ink or paint blends on the Shuan paper. This effect is exaggerated when you're painting on raw Shuan paper (see image at right). It takes time to learn how to control the amount of water, ink and color in the brush to paint the right strokes. Keep practicing and you will achieve perfection.

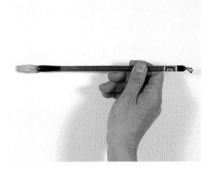

Creating Texture
The less water, ink and color in the brush, the rougher the texture (left stroke) and vice versa (right stroke).

Holding the Brush
Here are the side (above) and top (right) views of a correctly held brush.

Side Brush
Hold the brush sideways to achieve broad and rough-textured strokes.

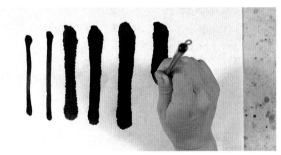

Center Brush
Painting center brush allows you to create full, round strokes in a variety of sizes.

Loading Several Colors on One Brush

When painting flowers, you can load several colors on one brush to create a petal with a single stroke. See steps 1–5 to load yellow, Vermilion, Carmine and Rouge on one brush. Use one stroke to paint a petal. You can practice this technique by following many of the Chinese spontaneous-style painting demonstrations in chapter four.

Places to Buy Chinese Painting Materials

Sometimes it's not easy to find Chinese painting materials. Often, your favorite local art supplier can order specific items for you. You can also order them from me at www.lianspainting.com.

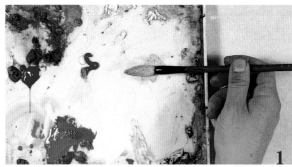

1 Load Yellow
Wet the brush completely and load yellow on its heel (the part of the brush head closest to the handle).

2 Load Vermilion
Load Vermilion next to the yellow on the upper-middle section.

3 Load Carmine
Load Carmine on the lower-middle section, next to the Vermilion.

4 Load Rouge
Load Rouge at the tip.

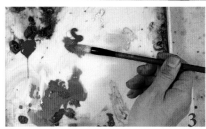

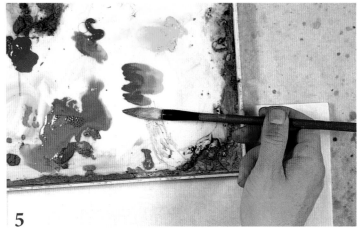

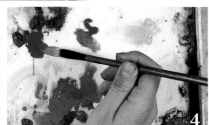

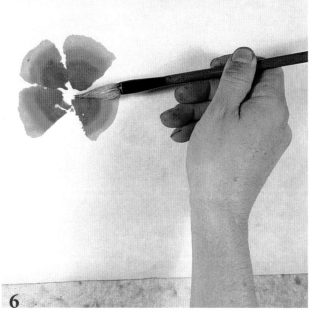

5 Blend the Colors
Finally, dab the whole brush on the palette a few times so that the colors blend into each other smoothly.

6 Make Side Strokes
After you've loaded the brush, hold it sideways to paint several strokes. Use the tip as a pivot point (pointing to the center of the flower), and drag the middle and heel.

WATERCOLOR MATERIALS AND TECHNIQUES

Paper

I use Arches 140-lb. (300gsm) cold-pressed watercolor paper because I like the sizing on the paper, and its strong surface holds up to masking fluid. When I paint flowers or other soft subjects like fish and birds, I use the smooth side with the watermark. When I paint landscapes I use the side with the rough texture.

Flatten the Paper Without Pre-Stretching

To prevent the paper from warping when it dries and to make pouring and blending color easier, tape or staple the watercolor paper on a firm board, such as three-ply plywood board or Gator board. I typically use clear packing tape or masking tape to attach each edge of the watercolor paper to the board (place the tape about ¼ inch [6mm] from the edge). Use the plastic handle of a brush to press the tape onto the paper and board, removing air bubbles for a secure attachment. If you use a stapler, shoot the staples approximately 1 inch (3cm) from each other at about ¼ inch (6mm) from the edge of the paper.

Colors

For years I have tried to minimize my palette. In fact, I completed every watercolor painting in this book using just three colors: blue, yellow and red. For the blue, I usually use Antwerp Blue (Winsor & Newton). Occasionally, I use Prussian Blue (Winsor & Newton) or Royal Blue (Holbein). For the yellow, I use Arylide Yellow (Da Vinci) and Azo Yellow Medium (Van Gogh). Permanent Yellow Lemon (Holbein) and Hansa Yellow Light Lemon (Da Vinci) are also on my list.

I use different red pigments depending on the color of the flower. For example, to paint pinkish flowers I use Quinacridone Rose Red Deep (Da Vinci). To paint orange-red flowers I use Naphthol Red Mid-Tone (Da Vinci) or Permanent Red Deep (Van Gogh).

Using Watercolor Pigments

There are many benefits to using a limited palette. With only three primary colors, you can create many secondary colors. Also, it's easier to achieve a dominant color in a painting. A limited palette also helps keep the painting from becoming muddy. For whites, I preserve the white of the paper. Sometimes I use masking fluid to help me do this. To get dark colors, I mix undiluted blue with a little undiluted red and a small amount of water (see below).

Pigments
These are three typical primary colors I use for watercolor painting. The dishes contain these colors diluted with clear water.

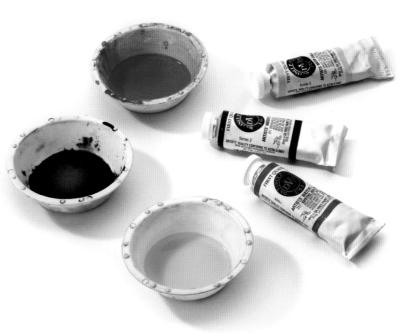

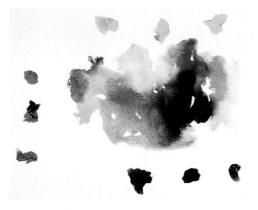

My Palette
Here you can also see how I lay out the three colors on a palette. I make three puddles of each color, two for mixing with other colors and one for pure coloring. This is one of the secrets to keeping paintings clean.

Diluting Paint

To prepare diluted paint for pouring and blending, I mix each color with clear water in a small dish, using a separate brush to stir each color. There are two rules of thumb for making diluted colors: First, to darken the value of a painting, use stronger values of the blue and red mixtures. (To lighten the value, use weaker values of the blue and red mixtures.) Second, never create anything darker than a medium value of yellow or it will become muddy.

Pouring and Blending

Before pouring the paint (see photo of diluted paint below), use a spray bottle to wet the paper lightly. Then pour the diluted paints next to each other on the wet area. The colors will follow the water and blend into each other. The more water and paint, the greater the blending.

For more dramatic color blending, tilt the watercolor paper so that the colors flow into each other. To keep the painting from becoming muddy, tilt the painting in one direction only. Otherwise, the colors will overmix.

Using Your Fingers and Mouth to Paint

After pouring diluted paints I use my fingers and brushes to direct the flowing and blending (see below). Using my fingers to paint is fun; it takes me back to my childhood art projects.

Another fun technique is blowing on the diluted paints to create effects like stems and grasses (see below). Place your mouth close to the paint and blow it onto the dry areas with a short, strong bursts of air.

At first, it won't be easy to control the pouring, blending and blowing techniques. Practice on small watercolor papers without painting any subjects until you become familiar with the techniques and can handle them comfortably.

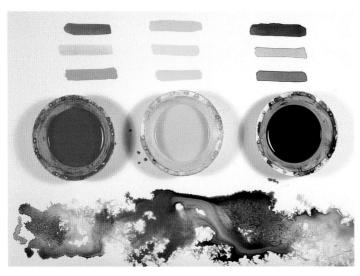

Diluted Paint Values and Blending

I usually try to create a medium value, as you can see on the lower testing strokes above the dishes. The strokes on the top show very strong color value, while the middle strokes show the very weak value.

In the upper middle where the blue, yellow and red meet, you can see the blending effect of a higher percentage of water. In contrast, less water and paint create a "fluffy" texture. You can see this effect at the right side of the red paint.

Blown-Paint Effects

Short, strong bursts of air can be used to create stems and grasses.

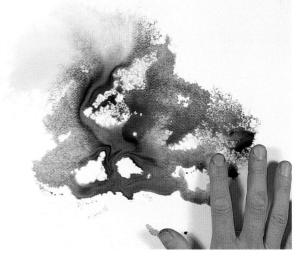

Hands-On Painting

Manipulating the paint with my fingers allows me to have direct contact with my painting so that I feel I am part of it.

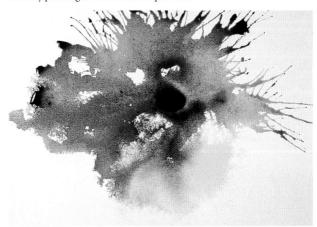

Brushes

I like synthetic sable brushes because they have good elasticity and are easy to handle. The brushes shown on this page are the ones I typically use. They are not fancy or expensive. I don't like to use Chinese brushes for watercolor painting because they retain a lot of water and their hairs are too soft to work with. Conversely, I don't like to use watercolor brushes for spontaneous-style painting because they can't be loaded with a lot of water, ink and colors, which is necessary for creating long strokes on strong, absorbent raw Shuan paper. The rough hairs in synthetic sable watercolor brushes will also easily break the delicate Shuan paper.

Masking Fluid

Use masking fluid to preserve detailed areas such as the focal-point flowers so that they aren't contaminated during the color pouring and blending process. I prefer a light yellow masking fluid, but I used a gray masking fluid for the watercolor demonstrations in this book since it shows up better in photographs. It doesn't matter what color of masking fluid you use, but keep in mind that brightly colored fluid can distract your eyes and interfere with your color perception.

Handling Masking Fluid

When you open a new bottle of masking fluid, the solids are usually condensed in the neck of the bottle. I use the handle of a small brush to stir the solids back into the liquid. Don't shake the bottle since this will create bubbles. After applying masking fluid, replace the cap immediately. It's not a good idea to use masking fluid that has been open for more than a year. Old masking fluid is difficult to apply and remove. Worst of all, it can become permanently stuck to the paper.

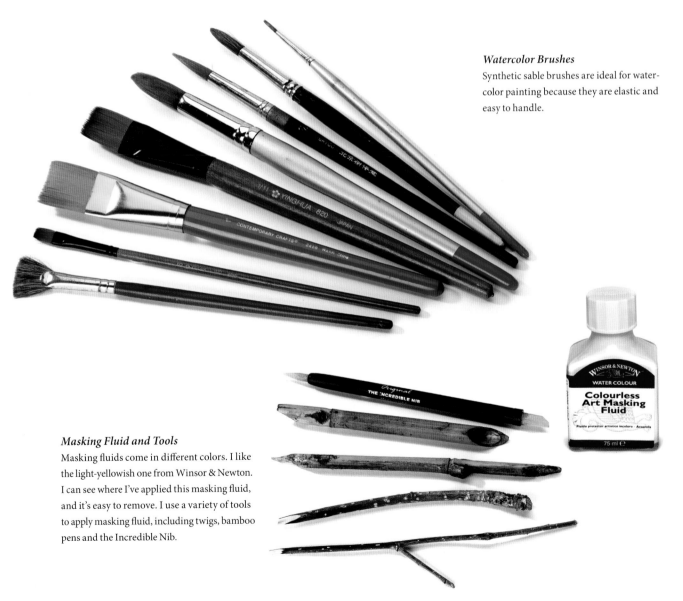

Watercolor Brushes
Synthetic sable brushes are ideal for watercolor painting because they are elastic and easy to handle.

Masking Fluid and Tools
Masking fluids come in different colors. I like the light-yellowish one from Winsor & Newton. I can see where I've applied this masking fluid, and it's easy to remove. I use a variety of tools to apply masking fluid, including twigs, bamboo pens and the Incredible Nib.

Applying Masking Fluid

I essentially use two tools to apply masking fluid. For large areas such as a whole flower, I use my fingers. For smaller areas such as stems and grasses, I use the wedge-shaped end of a brush handle. You can make tiny strokes with the end of a brush handle if you use its sharp edge, or you can make large strokes if you use the flat side.

Correcting Mistakes and Speeding Up the Drying Process

If you make a mistake while applying the masking fluid, wait for it to dry, then remove and reapply it. Masking dries in about an hour, depending on how thickly it is applied and how much moisture is in the air. Masking fluid manufacturers recommend letting the masking air-dry. However, I've also used a hair dryer, and even put it in direct sunlight for quick drying. I hold the hair dryer a minimum of 2 feet (61cm) away from the masking, and I don't expose the paper to sunlight for more than half an hour.

Removing Masking

To remove the masking, I use packing or masking tape. Cut the tape into pieces about 2 inches (5cm) long, then press the pieces on top of the dried masking and drag and peel the masking from the paper. To keep the masked area clean, peel the dried masking away from the center of the masked area outward toward its edges. Also, change to a new piece of tape after a few uses.

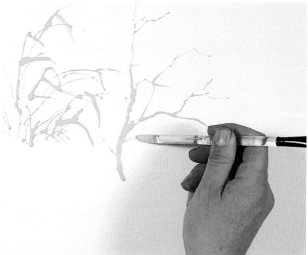

Masking With Fingers (top left)
I use my fingers to apply masking fluid to large areas.

Masking With Brush Handle (top right)
Use the end of a brush handle to create stems and grasses with masking fluid.

Removing Masking (bottom left)
Apply 2-inch (51mm) pieces of tape to the masking and peel the tape up to remove the masking.

NEGATIVE PAINTING

I frequently use negative painting to define objects and create beautiful effects, as you can see in many of the demonstrations in chapter four. Here is a simple way to implement this technique in watercolor. You can apply this technique similarly in Chinese painting.

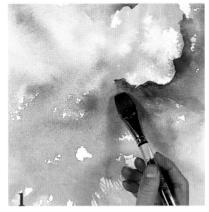

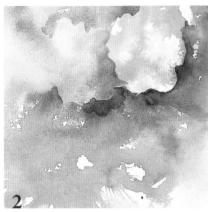

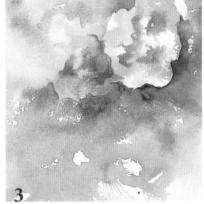

1 *Pour Colors and Call Out Flower Shape*
Pour or wash in the three primary colors (blue, yellow and red). After the paint dries, use a brush to call out the shapes of the flowers with blue (or a color with a darker value than the base colors). Lightly wet another brush and use it to blend the blue so that it gradually fades into the background colors without a hard edge.

2 *Define the Edges, Then Blend*
Use red to define the area where the two flowers touch. Leave a hard edge next to the closer flower, but blend the red into the flower behind so that it gradually blends into the base colors.

3 *Call Out the Petals*
Call out the petals of each flower. Use one brush to apply the red at the base of the petals, then lightly wet another brush and use it to blend the color toward the tips of the petals.

4 *Define the Leaves and Stems*
Use separate brushes to define leaves and stems, as in step 3. Use one brush to apply blue and another to blend the blue into the base colors.

NEGATIVE PAINTING TIPS

1. Paint around the object, but don't paint the object. To understand this concept, place one of your hands on a sheet of paper and open your fingers. Paint around your hand and fingers. Lift your hand up and you can see its shape created by the paint around it.

2. Retain the base colors as the object's color even if they don't realistically represent the colors of the actual object. For example, it's OK for leaves to remain blue or dark purple (instead of green). You will define the shape of the object by painting around it, and its shape will make its identity clear.

3. Preserve the object's edges, while blending them smoothly into the base colors at the background.

4. The blending brush should be only slightly wet. If it has too much water, it will blend the color too much and wash out the base colors.

STRETCHING A CHINESE PAINTING

When colors and ink dry on Shuan paper (both raw and mature), the paper wrinkles. Also, the pigments sink into the unpainted side of the raw paper, making the colors look drab. To remove the wrinkles and showcase the vivid colors, you have to stretch a finished Chinese painting. To do this, you'll attach another layer of Shuan paper to the back of the original painting.

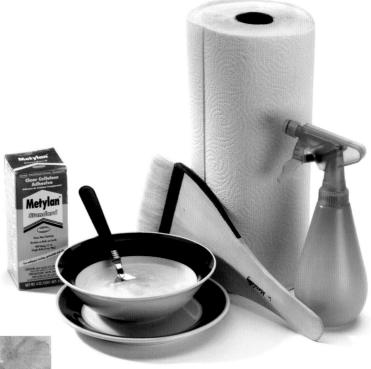

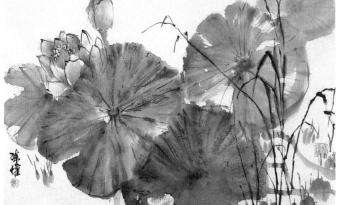

Stretching Materials (above)
This picture shows the materials you need to stretch a Chinese painting: wallpaper paste, a 3½-inch (9cm) hake brush, paper towels and a spray bottle.

Unstretched Painting (left)
Here's the painting we're stretching and the double-layer raw Shuan paper underneath.

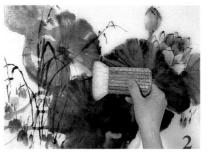

1 *Align Painting and Spray With Water*
Mark two edges and a corner of the painting on the glass with masking tape, about 2 inches (5cm) from the edges of the glass. Lay the painting upside down on the glass, aligning one corner and two edges with the pieces of tape. Spray with water until it's just wet.

2 *Apply Wallpaper Paste*
Use the large flat brush to apply the wallpaper paste to the back of the painting. Start from the center of the painting and brush out toward the right edges. Continue to apply the paste to the left side of the painting the same way.

3 *Brush Out Bubbles*
After brushing out the bubbles (air gaps between the painting and the glass), use a paper towel to wipe off the spilled paste around the painting. Be careful not to touch the painting or it will tear.

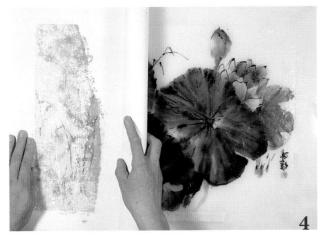

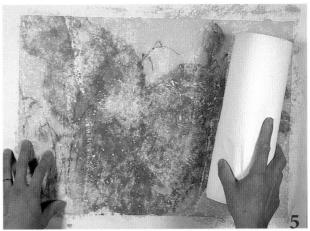

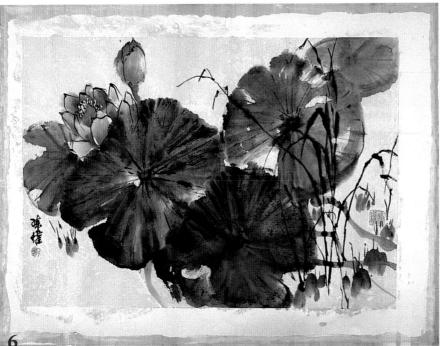

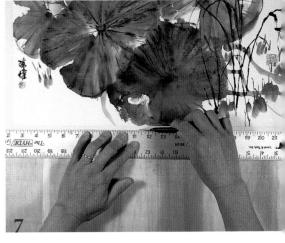

4 Begin Applying the Raw Shuan Paper to the Back of Painting

Roll up the raw Shuan paper and hold it in your right hand. Use your left hand to roughly align the lower-left corner of the raw Shuan paper with the lower-left corner of the glass. Slowly lay a small portion of the raw Shuan paper down onto the painting.

5 Continue Applying the Raw Shuan Paper

While slowly unrolling the raw Shuan paper onto the painting with your right hand, use your left hand and the paper towel roll to gently press the raw Shuan paper down onto the painting. After the raw Shuan paper attaches to the painting completely, use your right hand and the paper towel roll to further flatten the raw Shuan paper, attaching it strongly to the painting.

6 Attach Painting to the Plywood

Immediately brush a ¼-inch (6mm) border of wallpaper paste around the perimeters of the raw Shuan paper, then use both hands to lift up the raw Shuan paper and the painting together. (Start from one corner and then lift the whole painting.) Attach the perimeters of the raw Shuan paper to the 5-ply plywood. It will take several hours for the painting to dry, depending on the humidity.

7 Cut the Painting From the Board

When the painting and the raw Shuan paper are completely dry, the painting will be flat without any wrinkles. Cut it from the plywood by slicing the raw Shuan paper at about ¼-inch (6mm) from the edges of the painting. Now the painting can be matted and framed like a watercolor.

ORCHID *Chinese ink and color on raw Shuan paper* *14" × 20" (36cm × 51cm)*

2 SECRETS OF
CHINESE PAINTING
COMPOSITION

Chinese painting compositions are unique and create an aesthetic that is distinctly different from Western paintings. Among the secrets of creating these special compositions are: clear focal point, strong contrast, relative balance, three-line integration, grouping objects in geometric shapes, dynamic orientation and leaving white space. Study the lessons in this chapter to learn how to incorporate these composition secrets into your own painting.

FOCAL POINT

The focal point in a painting is like the commander in a group of soldiers. Without a leader, the soldiers fight individually rather than as a team. They must fight together to be successful in battle. Likewise, without a focal point, objects on a painting have no relationship or communication with each other. They look like they just happen to be there and lack interaction and connection.

Generally, the focal point is located in one of four primary spots: the intersections of nine equal divisions of the paintings (three horizontal and three vertical). The circles on the illustration above indicate the four spots. This concept holds true regardless of whether it is a vertical or horizontal composition. Compositions centered in one of these four spots are naturally pleasing to the viewer's eyes.

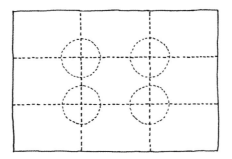

Western Connection
This division into thirds is also commonly used in Western painting. It is often referred to as the "rule of thirds."

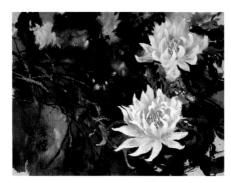

Focal point: Lower Right
The flower on the lower right is the focal point. Its petals are larger, its colors are more vivid, and it has more details than the flower above.

NIGHT NARCISSUS *Chinese ink and color on raw Shuan paper 14" × 18" (36cm × 46cm)*

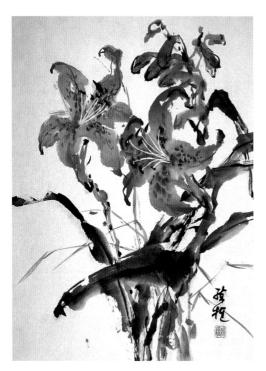

Focal point: Upper Right
In this painting the focal point is located in the upper right. The flower there is large, with intense colors and more details.

TIGER LILY *Chinese ink and color on raw Shuan paper 18" × 26" (46cm × 66cm)*

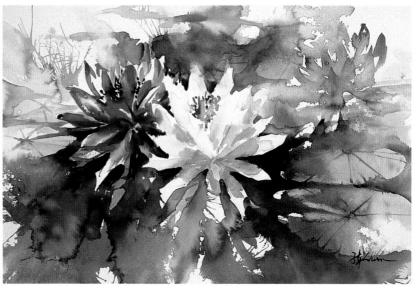

Focal Point: Lower Left
Similar to Chinese paintings, Western watercolor paintings can also have focal points falling on one of the four spots. The two flowers on the lower left dominate the objects in the painting.

WATER LILY *watercolor on Arches 140-lb. (300gsm) cold-pressed watercolor paper 14" × 21" (36cm × 53cm)*

SEVEN PRINCIPLES OF CONTRAST

Another Chinese painting composition secret is the emphasis on strong contrast between dark and light, large and small, long and short, singular and multiple, vertical and horizontal, defined and blurry, and shapes and lines. This principle is based on an ancient Chinese belief: things in the universe are created in opposing but complementary pairs e.g., light and dark, fire and water, life and death. The yin and yang symbol (right) represents this concept: The two parts are opposite but rely on each other for existence and survival. On the following pages you can see examples of the seven principles of contrast.

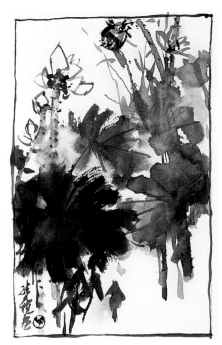

Dark vs. Light

The very dark lotus leaves on the left contrast strongly with the light leaves on the right. Together they create a harmonic existence. If all the leaves were the same value, the composition would be plain and boring.

Yin and Yang

This well-known symbol represents the Chinese philosophy that the elements of the universe are created in opposing but complementary pairs.

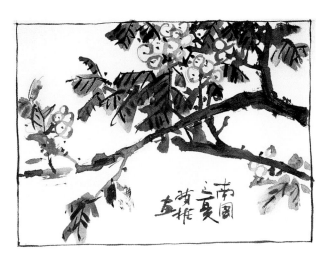

Long vs. Short

This painting has two main branches, one of which is longer than the other. If they were the same length the composition would seem mechanical.

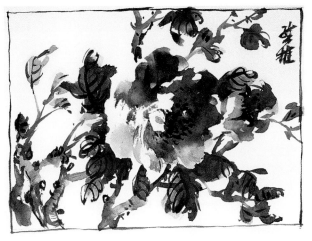

Large vs. Small

The larger flower near the center contrasts with the smaller flower next to it on the right. Also, it allows the larger flower to dominate the composition. The smaller flower brings more attention to the larger flower and makes it seem even bigger.

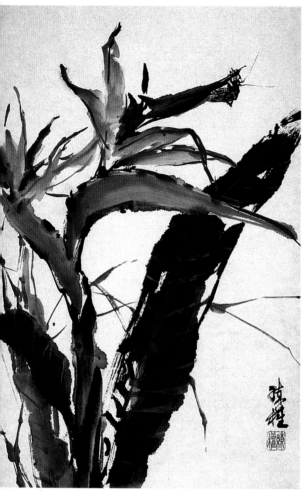

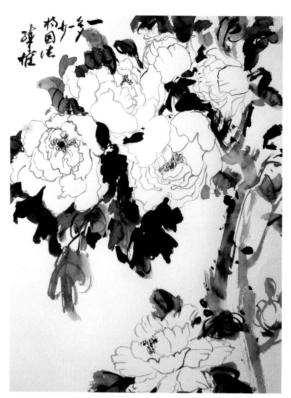

Singular vs. Multiple

In grouping the objects, it's best to avoid assigning the same number of objects to each group. This composition has a lot of flowers on the upper part and just a few flowers on the bottom. The void in the lower portion of the painting creates a break for the eyes.

Vertical vs. Horizontal

This composition shows two major forces crossing each other in an interesting way. The flowers from left to right form a strong horizontal. The stem and leaves form a strong vertical. These lines create tension, as well as attraction. The horizontal and vertical lines are not straight lines defined by three points, as in math. They relate to forces (lines) crossing each other in a non-right angle. Basically, the lines don't have to be completely straight or completely vertical or horizontal.

BIRD-OF-PARADISE *Chinese ink and color on single-layer raw Shuan paper 22" × 16" (56cm × 41cm)*

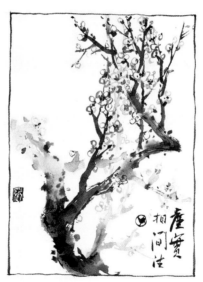

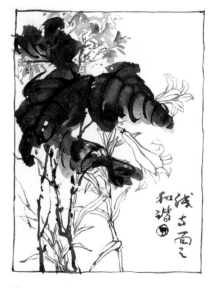

Defined vs. Blurry

Objects in a painting are defined by different levels of detail and value. This variation in detail and value creates depth as well as a clear focal point. Here, part of the large branch is painted with intense, dark ink while the other portion is blurry and light. The same principle can be seen in the smaller branches. This effect is similar to a close-up picture: The focused object is clear while the rest of the image is blurry.

Shapes vs. Lines

Chinese painting relies heavily on brushstrokes to define subjects. When strokes are large they can become shapes or surfaces. The four leaves shown here were painted with a few strokes and they appear as shapes that are much larger than the strokes outlining the flowers. The contrast between the shapes and lines makes the painting sing.

BALANCE

Balance between objects is an important part of Chinese painting composition. This balance is not perfectly even (right). On the other hand, a composition totally out of balance doesn't feel comfortable (far right). Balance in Chinese painting composition is a relative balance. Imagine trying to balance two objects of different weights on a scale. You must locate the heavier one closer to the pivot point, while the smaller object should be farther away to make the objects balance. The three paintings below illustrate different ways relative balance can be accomplished.

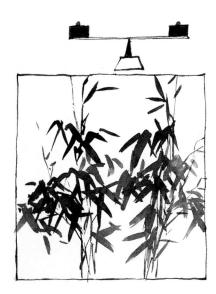

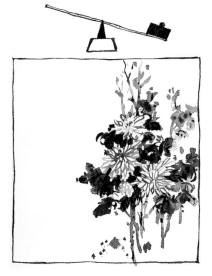

Evenly Balanced Composition
The perfectly even balance of the two groups of bamboo is uniform and boring. Chinese painting composition involves relative balance.

Unbalanced Composition
The left side of the painting is empty, and the viewer's eyes will seek something there. To fill the void, include another smaller group of flowers, some calligraphy, and your signature and chop.

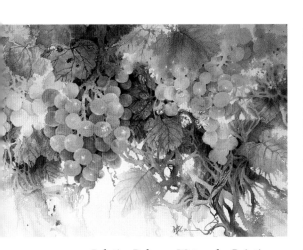

Relative Balance: Watercolor Painting
The composition principle implemented in this watercolor is similar to that of the Chinese painting (near right) and it works well.

GRAPES *watercolor on Arches 140-lb. (300gsm) cold-pressed watercolor paper 14″ × 21″ (36cm × 53cm)*

Relative Balance
The bamboo on the right is painted with dark ink and has a heavy appearance. On the left, the bamboo is depicted with light ink. The lighter bamboo combines with the calligraphy, signature and chop as a whole to balance the right side.

Relative Balance
Here, the heavier center is balanced by objects on both sides.

THREE-LINE INTEGRATION

Another Chinese painting composition secret is the three-line or three-force integration that leads the viewer's eye around the composition. Objects in a painting are organized into three groups (one major and two minor). These three groups act like three lines crossing each other to create harmonious interactions. Keep the following in mind as you arrange the three groups: at least two of them should overlap, they should not be parallel, they should all move in a similar direction, and one group should be dominant and the other two supporting.

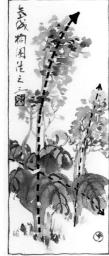
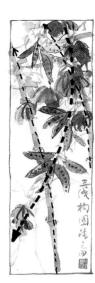
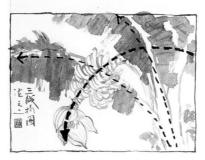

Three-Line Integration at Work
Here you can see four compositions using three-line integration. The heavier dotted lines with larger arrowheads indicate the major lines (groups).

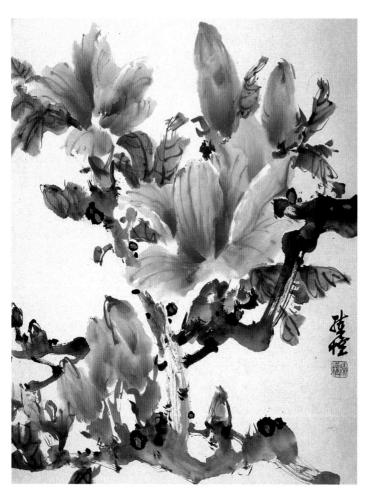

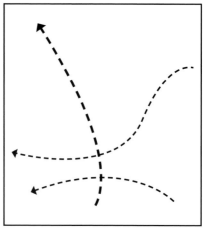

Magnolia Three-Line Diagram (above)

Harmonious Interactions

The heavy dotted line in the middle of the painting indicates the major group of magnolia flowers that extends from the bottom left through the middle right and upper left. It helps to enforce the focal-point flowers in the middle right. A minor line (group) of branches, leaves and buds extends from the upper middle right down to the lower left. The branch extending from the lower right corner to the lower left forms another minor group. The two minor lines integrate and overlap with the major line, creating an interesting composition.

MAGNOLIA *Chinese ink and color on single-layer raw Shuan paper 29" × 20" (74cm × 51cm)*

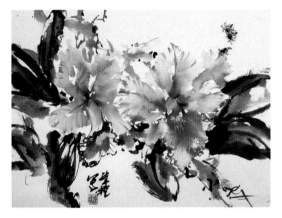

Directing the Viewer's Eye

The two orchid blossoms, along with the large leaves on either side, form the major line. The two flowers create the focal point. Two minor lines formed by the stems, roots and leaves start at the bottom of the painting and move through the flowers to the top. These minor lines direct the viewer's eye to the focal point.

DOUBLE ORCHIDS *Chinese ink and color on single-layer raw Shuan paper 18" × 24" (46cm × 61cm)*

Double Orchids Three-Line Diagram (left)

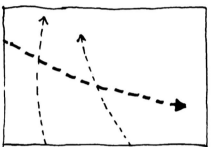

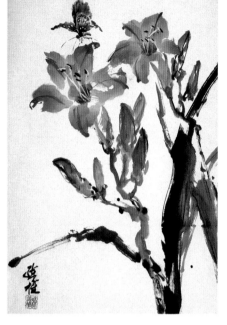

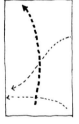

Tiger Lily Three-Line Diagrams

Major and Minor Lines

The tiger lily stem extending from the bottom right to the upper left creates the major line and focal point of the painting. The smaller lily and stem in the background is a minor line that is parallel to the major line. A parallel line tends to look stiff in a composition. Therefore, it needs another minor line. The third line, formed by the large leaf extending from the lower right to upper right, breaks the rigidity.

TIGER LILY *Chinese ink and color on single-layer raw Shuan paper 20" × 13" (51cm × 33cm)*

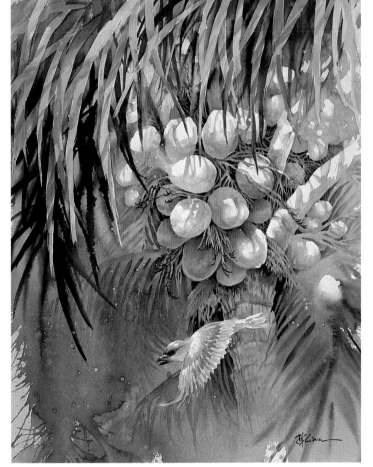

Three-Line Integration in Watercolor Compositions

Three-line integration creates beautiful compositions in Chinese painting, so I use it in watercolor paintings as well. In this example, the trunk and the coconuts together form an upward line, the major force in the composition. The leaves on the top form a minor line, extending from right to middle left. The stem and the leaf on the lower right and the bird become the other minor line.

COCONUT TREE AND BIRD *watercolor on Arches 140-lb. (300gsm) cold-pressed watercolor paper 24" × 18" (61cm × 46cm)*

GEOMETRIC ORGANIZATION

Organizing objects geometrically in a composition is another Chinese painting composition secret. These formations create interesting and beautiful paintings that keep the eye flowing through the picture plane.

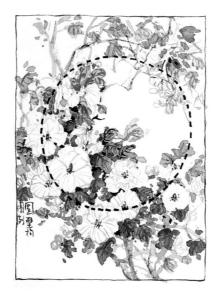 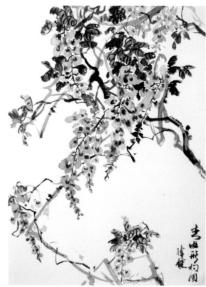

Geometric Composition Comparison (above)

Let's analyze two sketches to see how the use of geometric organization affects the composition. The hollyhocks on the left are arranged in a circle, while the flowers on the right are layed out in an S-shape. The circle causes the eye to move around the composition, reinforcing the focal point on the lower left. Similarly, the S-shape forms an interesting path for the viewer's eye, leading it to the point of interest on the lower right.

Arc Shape (left)

Here the flowers and leaves are painted in an arc shape. This composition is more attractive than painting them the way sunflowers actually grow, straight up and down.

SUNFLOWER *Chinese ink and color on single-layer raw Shuan paper 27" × 19" (69cm × 48cm)*

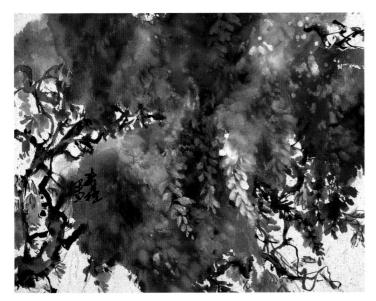

Rectangular Shape

The wisteria spreads out to the four corners of the paper, forming a rectangular shape. This shape has the power to grasp the viewer's attention at first glance because of its fullness.

WISTERIA *Chinese ink and color on single-layer raw Shuan paper*
10" × 14" (25cm × 36cm)

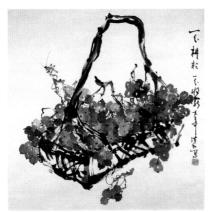

Triangular Shape

A basket containing grapes is larger at the bottom, forming the base of the triangle. It becomes smaller at the top, suggesting the tip of the triangle. The triangular shape lends a sense of stability to the objects.

GRAPES AND BASKET *Chinese ink and color on single-layer raw Shuan paper*
24" × 36" (61cm × 91cm)

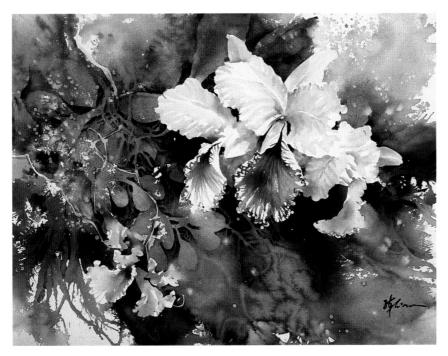

Geometric Organization in Watercolor Compositions

The arc starts with the three orchid flowers in the middle right and continues to the left with the roots and stems. It then curves down toward the lower left with more roots, flower buds and another flower. It ends at the bottom right. Arranging objects on an arc creates a circular, flowing motion. Viewers start with the focal-point flowers in the upper right. After they have enjoyed those details, their eyes move around the arc, taking in the whole picture.

ORCHID FLOWERS *watercolor on Arches 140-lb. (300gsm) cold-pressed watercolor paper 18" × 24" (46cm × 61cm)*

DYNAMIC MOVEMENT

Another important principle in Chinese composition is the dynamic movement of the objects as a whole in one main direction. This creates tension and communication between objects and emphasizes the focal point.

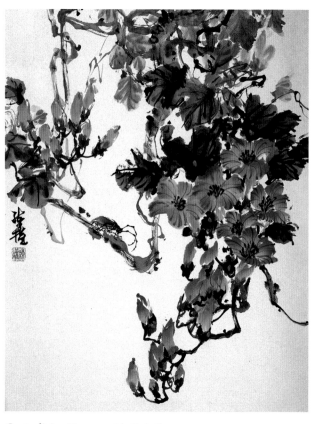

Centralizing Movement

This ink sketch is a good example of centralizing movement: The leaves, stems and grasses all lead the viewer's eye toward the center of the painting, where the flower and the dragonfly form the focal point.

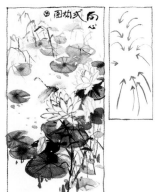

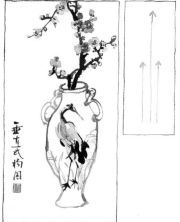

Centralizing Movement in Painting

Compare this painting to the ink sketch on the left. You can see the similarities.

TRUMPET CREEPER *Chinese ink and color on raw Shuan paper 18″ × 26″ (46cm × 66cm)*

Upward Movement

In addition to centric orientation, upward, downward and horizontal directions are also commonly used. These three images are all upward moving compositions. However, each varies slightly at the top: The corn stock (above left) shifts toward the left, the vase and the flowers (above right) are straight up and down, and the hibiscus (right) shifts to the right.

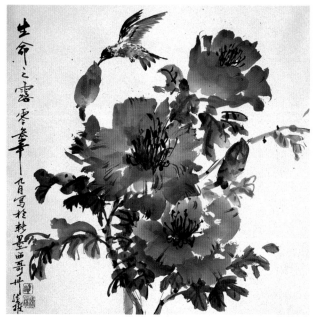

HIBISCUS *Chinese ink and color on raw Shuan paper 24″ × 24″ (61cm × 61cm)*

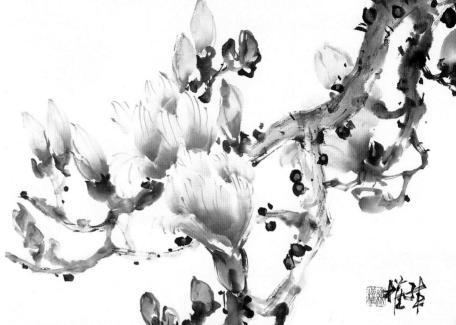

MAGNOLIA *Chinese ink and color on single-layer raw Shuan paper 14″ × 18″ (36cm × 46cm)*

Downward Movement

These three paintings are all downward moving compositions. In the painting on the lower left, the morning glories hang down toward the right. In the painting on the upper left, a branch moves from the upper right toward the lower left, leading viewers' eyes to the small insect. In the painting above, the flowers and branches move from upper right to lower left.

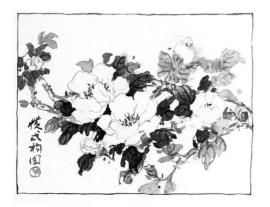

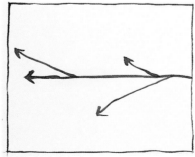

Horizontal Movement

This ink painting (far left) is an example of a horizontally oriented composition. Its main force moves from right to left, branching out a little on the way.

LEAVING WHITE SPACE

The last but most important principle of Chinese painting composition is leaving white space on the paintings. "Count the unpainted area as painted" is a very common phrase among Chinese painting artists. The unpainted area on a painting provides a place for the eye to rest. More importantly, it invites the viewer to use his imagination to complete the painting. As a result, he is more attracted to the painting since the longer he looks at the painting, the more he can feel and "see."

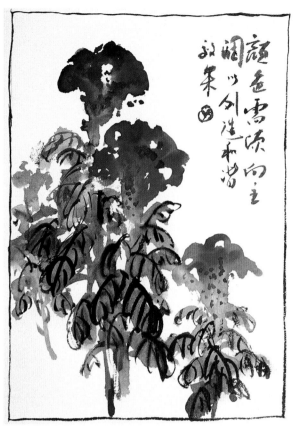

Room for the Imagination

This painting has a lot of unpainted spaces where your eyes can rest after viewing the vividly colored flowers. You can also imagine whatever you want to see in those spaces, such as other flowers, small animals, birds and insects.

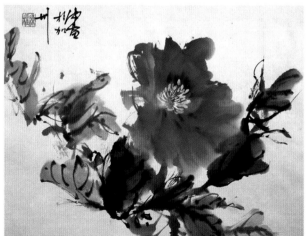

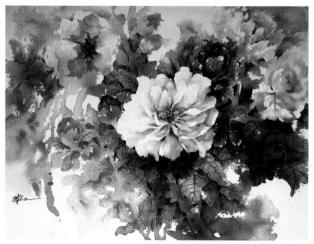

Two Mediums, One Technique

Leaving whites is also essential for watercolor composition. Here are two paintings of the same subject, one done in Chinese ink and color and the other in watercolor. Both have white spaces. In a way, the whites on the painting are like secrets that are being kept from you. You are interested in finding the secrets out, but you have to speculate about them by yourself. The more you want to know, the more curious you become and the more attractive the painting is to you.

PEONY (ABOVE) *watercolor on Arches 140-lb. (300gsm)*
cold-pressed watercolor paper 14″ × 21″ (36cm × 53cm)

PEONY (LEFT) *Chinese ink and color on raw Shuan paper*
16″ × 20″ (41cm × 51cm)

COMPOSITION METHODS IN ACTION

Now that you've learned the secrets of Chinese painting composition, let's implement them with hands-on experiments. This composition method provides maximum opportunities to create numerous compositions from the same sketches by flipping and rearranging the sketches. Also, it reduces the amount of sketching and erasing on Shuan and watercolor papers, which saves time and prevents paper surface damage. Here are the basic steps for creating compositions with this method:

1 Choose a 15" × 22" (38cm × 56cm) sheet of Shuan or watercolor paper (this is equal to half a sheet of watercolor paper). Now get a piece of tracing paper in the same size (either by cutting a large sheet or pasting smaller ones together).

2 Lay the tracing paper on top of the Shuan or watercolor paper.

3 Choose several flowers among the sketches and arrange them on the tracing paper as focal points.

4 Arrange other sketches of leaves and stems on the tracing paper to complete the composition.

5 Use clear tape to attach the sketches to the tracing paper.

6 Put the tracing paper with the sketches on a lightbox or a window, and lay the Shuan paper or watercolor paper on top.

7 Trace the composition onto the Shuan or watercolor paper. You can use pencil to trace on watercolor paper. See "Chinese Painting Materials" (page 18) to see how to trace the images onto Shuan papers.

Below are four different compositions I got from the same sketches using this method.

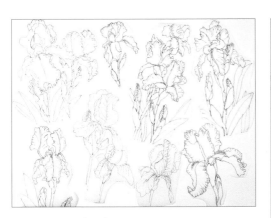

Iris Sketches
Here are different sketches of iris flowers, leaves and stems on tracing paper. I did them on large pieces of paper, which I trimmed down. Now I will use these sketches to form a variety of compositions.

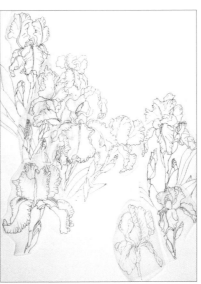

Vertical Compositions
In both compositions, I placed objects higher on the left and lower on the right. However, by placing more flowers in the upper left in one image (left) and more in the lower right in the other (right), I've created a different focal point for each.

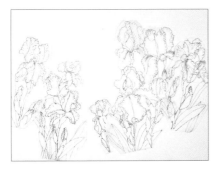

Horizontal Compositions
In both of these compositions the objects are arranged on an arc-shaped path, moving from the upper left down to the middle center and curving up again to the upper right. When we change the quantity of flowers at different locations we create a different focal point in each composition.

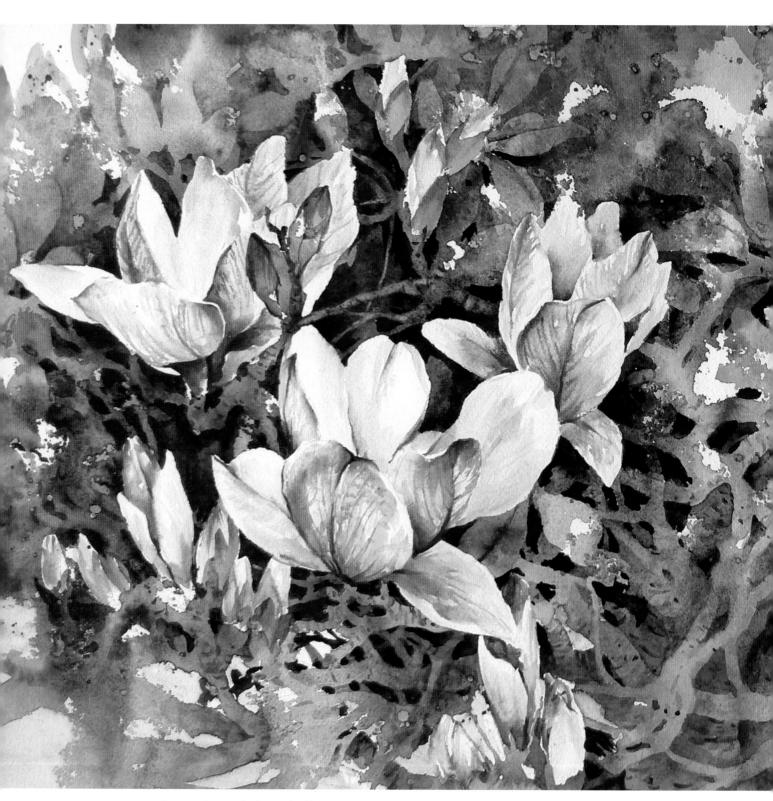

MAGNOLIA *watercolor on Arches 140-lb. (300gsm) cold-pressed watercolor paper 15" × 22" (38cm × 56cm)*

3 DEMONSTRATIONS

Having learned the basics of Chinese and watercolor painting, it's time to implement the theories and practice the techniques. When you follow the step-by-step demonstrations in this chapter you may not achieve the same results as I did. I can't duplicate them either. Focus on learning the principles rather than copying every detail. Try using different colors. Or, instead of copying my brush-loading sequence of light pigment at the brush heel gradating to dark at the tip, you can experiment by loading your brush in the reverse order.

Most artists develop their own painting method. I encourage you to temporarily forget the way you normally paint when following my demonstrations. Learn the principles and essence of my techniques, then integrate them with your principles and techniques to create your own style. Don't think of trying to create a masterpiece every time you paint, especially when you're learning another artist's techniques.

Finally, I strongly advise watercolor artists to study Chinese painting. It will help you learn to control water, manipulate the brush, and avoid overworking. Most importantly, it will teach you to discard paintings that have even a few wrong brushstrokes. Keep practicing and you will achieve your goal.

IRIS

Learning detail style is the foundation training for Chinese artists. It's equivalent to learning to sketch in Western art. In the beginning, students learn how to use ink and brush to sketch objects with strokes (lines). When they have sufficiently developed their skills, they are ready to develop detail-style paintings. After they have reached a high level of proficiency, they are ready to develop spontaneous-style paintings.

⚜ MATERIALS

PAPER

mature Shuan paper, 16" × 23" (41cm × 58cm)

BRUSHES

small • medium • large

CHINESE PAINTS

White • Yellow • Burnt Sienna • Vermilion • Carmine, Rouge • Phthalo Blue • Blue • Green Label Three • Indigo

OTHER SUPPLIES

Chinese ink • tracing paper • ballpoint pen • transparent tape • drawing tape • pencil (optional)

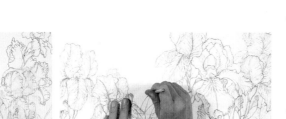

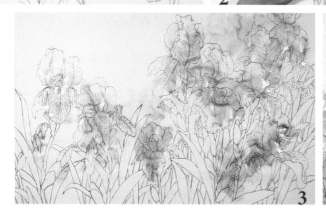

1 *FORM THE COMPOSITION WITH TRACING PAPER*

Use a ballpoint pen or pencil to sketch the iris flowers on tracing paper, then cut them out separately. Arrange the cut-out sketches on a 16" × 23" (41cm × 58cm) piece of tracing paper to form a composition. Attach the sketches to the tracing paper with transparent tape. Lay the mature Shuan paper on top of the tracing paper and attach them together with several small pieces of drawing tape.

2 *TRACE THE COMPOSITION IN INK*

Dip a brush into a small amount of medium-toned ink and hold it straight to trace the entire composition. Use one hand to hold down the mature Shuan paper while resting the wrist or forearm of the other hand (the one holding the brush) on the paper. Move the forearm and the hand together when painting long strokes.

3 *APPLY FOUNDATION COLORS*

When the strokes are dry, use a large brush to apply Carmine and yellow to the flower area and Phthalo Blue and yellow to the leaves.

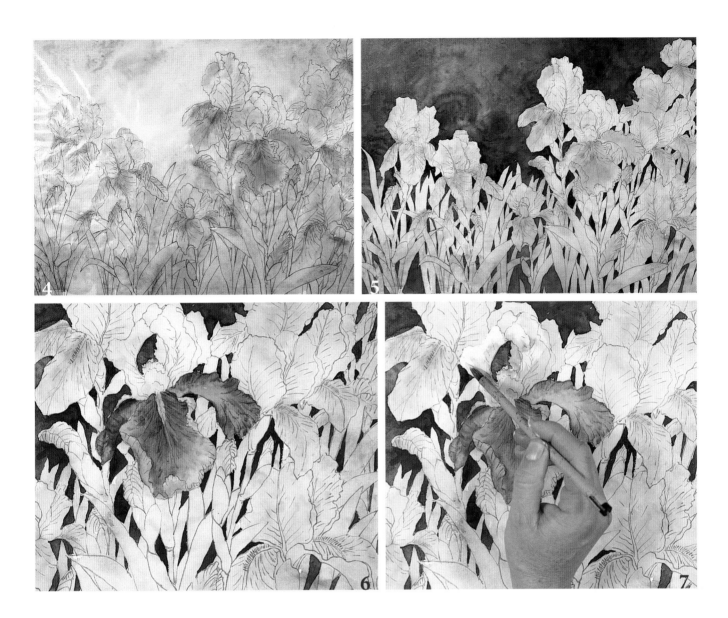

4 PAINT THE BACKGROUND FOUNDATION COLORS
Paint the foundation colors of the background in the same manner with yellow, blue and Carmine. Blend them smoothly into each other.

5 ADD ANOTHER LAYER TO INTENSIFY COLOR
When the background colors are dry, use small and medium brushes to apply Rouge, blue, Phthalo Blue and ink to intensify the value.

6 START PAINTING THE PETALS
Use a medium brush to paint the first three petals of the central flower with Rouge and Carmine. Lightly wet another medium brush to blend the two colors smoothly into the foundation colors.

7 CONTINUE PAINTING PETALS
The petals above those three are lighter and are orange-yellow. Apply yellow and Vermilion at the bases and white at the tips. Blend the colors smoothly where they meet.

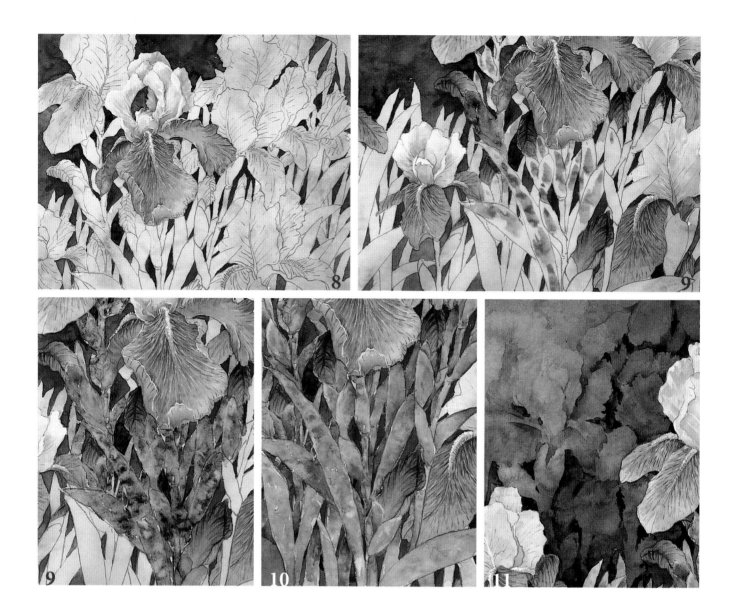

8 ADD TEXTURE TO THE PETALS

When the colors are dry, use a small brush to paint texture on the petals with undiluted yellow and white. Use more white pigment on petals with light base colors, and less white pigment on petals with dark base colors.

9 PAINT THE STEMS AND LEAVES

Use a couple of medium brushes to paint the stems and leaves. First apply Burnt Sienna and then yellow, Green Label Three and ink wet-into-wet. The colors will blend into each other loosely and create beautiful textures.

10 DEFINE THE LEAVES AND STEMS

When the colors are dry, define the leaves and stems by separating them. Use a medium brush to paint Indigo into the portions of the leaves and stems behind the overlapping areas. Immediately use another slightly wet medium brush to blend the Indigo away from the overlapping regions into the base colors.

11 LOOSELY CALL OUT DISTANT FLOWERS, STEMS AND LEAVES

In the upper portion of the background, use the negative painting technique (see pages 24–25) to loosely call out the distant flowers, stems and leaves. Paint around the objects with a mixture of ink and Indigo. Leave hard edges next to the other objects, but smoothly blend the remaining edge into the background colors. The darker the background color, the more Ink should be used for the negative painting.

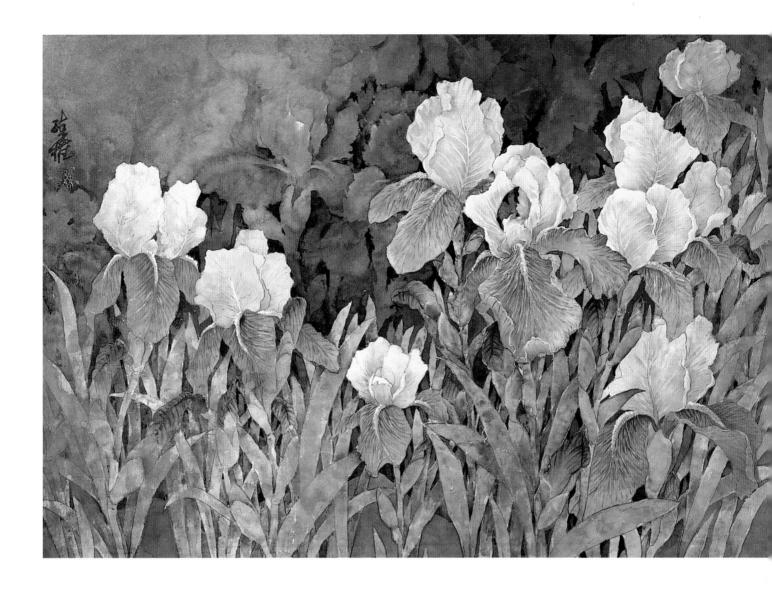

12 HIGHLIGHT THE BACKGROUND FLOWERS AND PAINT THE ROCKS

Highlight the background flowers with yellow and white. Use the negative painting technique to define the rocks at the lower portion behind the leaves and stems. Use a medium brush to mix ink and Indigo, and paint the rock edges. Lightly wet another medium brush to blend this color into the background.

IRIS *Chinese ink and color on mature Shuan paper 16" × 23" (41cm × 58cm)*

LOTUS

This style of Chinese painting influences my watercolor floral painting more than any other. Its combination of detailed flowers with a spontaneous background creates a unique contrast between tight and loose, defined and blurry. Viewers enjoy the details of the flowers, and they are able to "breath" and use their imaginations to complete the background. I think we can extend this approach to our everyday lives: work hard and relax well.

✿ MATERIALS

PAPER
mature Shuan paper, 14" × 18"
(36cm × 46cm)

BRUSHES
small • medium • large • extra large

CHINESE PAINTS
White • Yellow • Vermilion • Carmine •
Rouge • Green Label Three • Indigo

OTHER SUPPLIES
Chinese ink • tracing paper • ballpoint
pen • pencil (optional) • spray bottle

1 *SKETCH THE COMPOSITION AND TRANSFER IT TO SHUAN PAPER*

Sketch the composition with a ballpoint pen on tracing paper. Lay the mature Shuan paper on top of the sketch with the side up. Use a small brush to trace the objects onto the mature Shuan paper with medium-toned ink (dilute the ink with water). Hold the brush straight so that it's easy to make thin, uniform strokes. Apply a little more pressure to form thicker lines at the turns and folds of the petals.

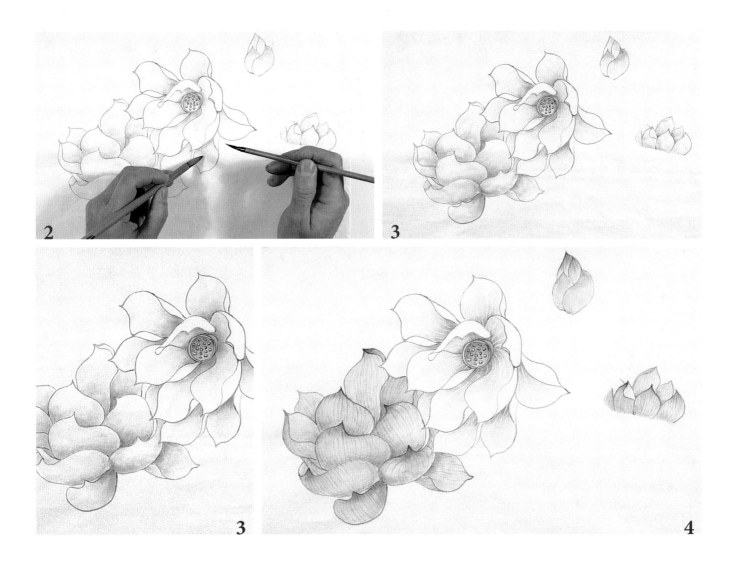

2 TONE THE FLOWERS AND BUDS WITH INK

Tone the flowers and buds with ink. Use the small brush to apply medium-toned ink at the base of each petal. Immediately use a slightly wet medium brush to blend the ink into the middle of the leaf, but leave white on the tip.

3 PAINT THE PETALS, STAMEN AND SEEDS

When the ink is dry, use the small brush to apply light yellow at the bases of the petals. With a medium brush, gradually blend the yellow into the middle part of the petals, leaving white on the tips. Wait until the paint dries, and repeat the process with more yellow. Apply a little Indigo at the stamen. Paint the seeds with yellow and white.

4 PAINT THE RED FLOWER AND ADD TEXTURE TO BOTH FLOWERS

Next, use a small brush to paint the tips of the reddish flower with Carmine and a little Rouge. Lightly wet a medium brush and use it to drag and blend the color down to the middle areas. When the paint is dry, take a small brush and paint the texture lines on the petals using Carmine for the reddish lotus and white for the yellowish flower.

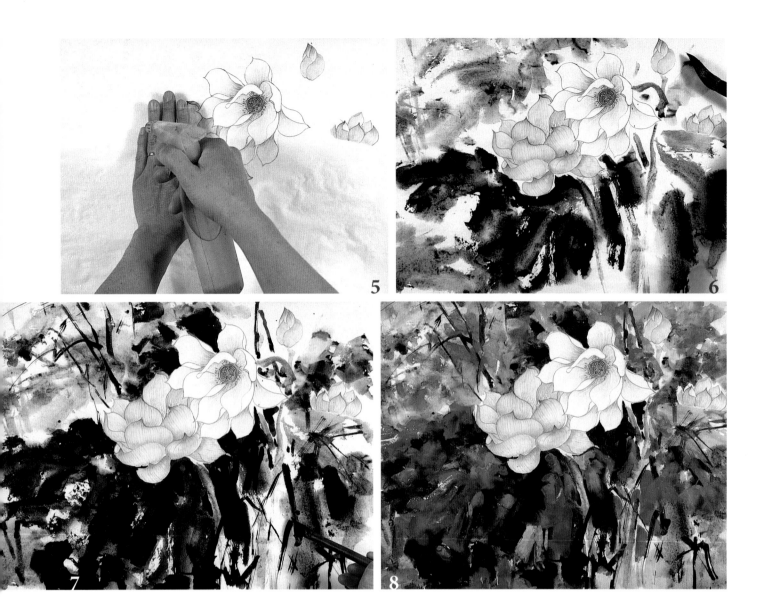

5 SPRAY WATER AROUND THE FLOWERS AND BUDS
Start painting the leaves and background by spraying water around the flowers and buds. Use one hand to shield the flowers and buds so that they don't get wet.

6 PAINT THE LEAVES AND STEMS WITH INK
Use an extra-large brush to paint the leaves and stems. Wet the brush and load ink onto its tip and middle. Hold it sideways to paint the objects. The distant leaves in the upper section should be lighter in value. Dilute the ink with water to produce this lighter color.

7 ADD MORE LEAVES AND STEMS AND PAINT THE GRASSES WITH INK
While the ink is wet, use a large brush to add more leaves and stems with dark ink. Also, paint the grasses with minimal strokes (one or two strokes per stem or leaf).

8 PAINT THE LEAVES WITH COLOR
Immediately load a large brush with green and paint the dark leaves. Mix Green Label Three with yellow to paint the other leaves.

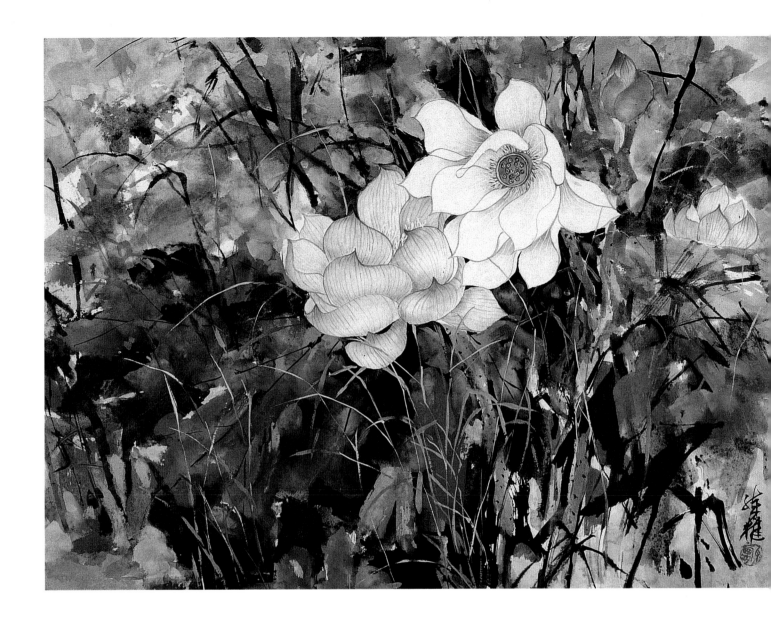

9 *PAINT THE GRASSES WITH COLOR AND SIGN THE PAINTING*

When the paint and ink on the leaves and background are approximately 80 percent dry, use the small brush to mix Vermilion and yellow to paint the light grasses. Sign and place your chop at the bottom right to balance the composition.

LOTUS *Chinese ink and color on mature Shuan paper 14" × 18" (36cm × 46cm)*

MAGNOLIA

In this demonstration you'll learn how to load two colors on a brush and use one stroke to paint a single magnolia petal. This is a basic Chinese painting technique for painting flowers. Once you master it you can load even more colors on one brush to paint other flowers in a similar manner.

❀ MATERIALS

PAPER
single-layer raw Shuan paper, 21" × 16" (53cm × 41cm)

BRUSHES
small • medium • large

CHINESE PAINTS
Blue • Rouge • Vermilion • White • Yellow

OTHER SUPPLIES
Chinese ink

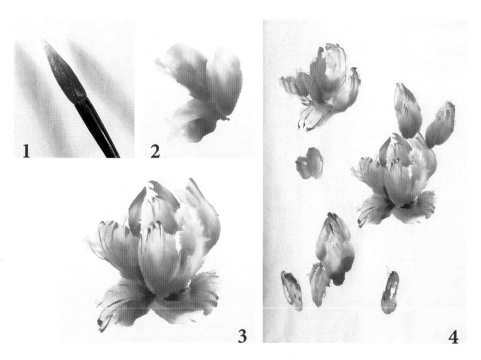

1 WET THE LARGE BRUSH AND LOAD TWO COLORS
Dip the brush in water and let the excess water run off. Then load the tip with white and the heel (the part of the brush head closest to the handle) with Rouge. (For more information on loading a brush see page 20.) Dab the brush on the palette to allow the colors to blend where they meet.

2 PAINT FLOWER PETALS
Holding the brush sideways as shown in Step 1, paint three brush strokes to form flower petals (one stroke per petal). Lay the entire brush head on the paper, with the tip at the top. (It's almost like stamping with a brush.) Start with the petal on the right and work your way to the left. You can see the watermarks at the overlap between each stroke, a unique characteristic that only raw Shuan paper exhibits.

3 REPLENISH WATER, LOAD THE BRUSH
Dip the brush tip lightly in water and tilt it upside down to allow the water to flow back into the brush head. Then reload the brush and continue painting the other petals as described in Step 2. Immediately use a small brush to add texture to the petals with Rouge.

4 PAINT UPPER FLOWER, ADD TEXTURE
Use the large brush to paint the flower in the upper left with the same technique you used for the first flower. To paint the buds, hold the brush sideways as you paint the petals, painting only two or three strokes for each bud. Use the small brush to paint the texture lines with Rouge while the petal colors are still wet.

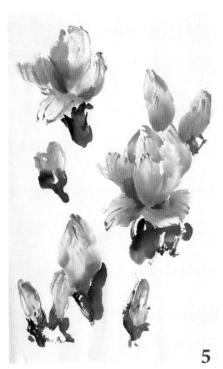

5

6

7

8

5 PAINT THE SEPALS

Wet a medium brush and load it with yellow. Then load it with Vermilion up to the middle and a little Rouge at the tip. Blend the colors by dabbing the brush on the palette a few times. Lightly dip the brush tip in the ink. Holding the brush sideways, with the tip pointing toward the bottom of the flower or bud, paint two or three strokes to form the sepals.

6 ADD STEMS

Wet a large brush and load ink at the tip. The water in the brush automatically blends the ink from the tip to the upper middle of the brush head. This creates a variety of ink tones from very dark at the tip to light at the middle. Hold the brush vertically ("center brush" see page 19) to paint the dark stems. The brush will be at a right angle to the surface. Add a little water to the brush to paint the light stems. Next, load the brush tip with a little ink to paint the dots on the stems. These are called "happy dots" and suggest the texture and energy of the objects.

7 PAINT MORE STEMS, BUDS

Use the large brush to paint more stems as in previous steps. Also, use a medium brush to add more buds as shown in Step 4.

8 SIGN AND BALANCE YOUR WORK (NEXT PAGE)

Use the medium brush and thick blue to paint the happy dots. Sign and stamp in the upper right where more objects are needed to balance the composition.

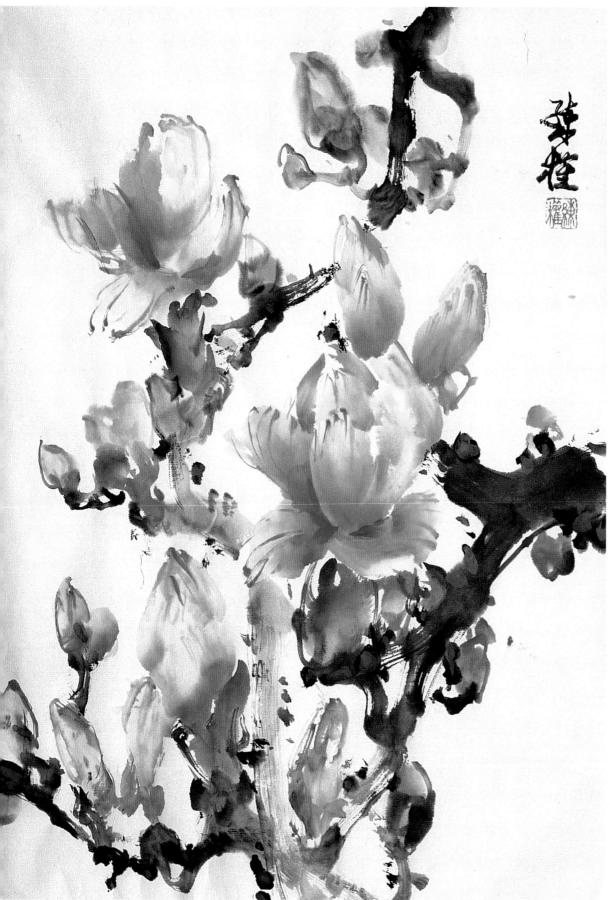

MAGNOLIA *Chinese ink and color on single-layer raw Shuan paper* 21″ × 16″ (53cm × 41cm)

MAGNOLIA

In this demonstration you'll use masking fluid to cover the magnolia flowers and paint the background first, using color pouring and blending techniques. After the colors dry, you'll lift the masking and paint the flower details. Masking fluid works well on watercolor paper, but can't be used on Shuan paper because lifting the masking will tear the delicate paper.

✼ MATERIALS

PAPER
Arches 140-lb. (300gsm) cold-pressed watercolor paper, 15" × 22" (38cm × 56cm)

BRUSHES
nos. 2 and 8 rounds • 1-inch (25mm) and ¾-inch (19mm) flats

WATERCOLORS
Arylide Yellow (Da Vinci) • Quinacridone Rose Red Deep (Da Vinci) • Antwerp Blue (Winsor & Newton)

OTHER SUPPLIES
masking fluid • no. 2 pencil • spray bottle

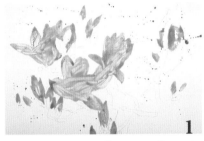
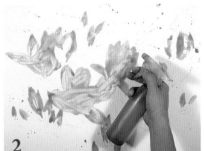
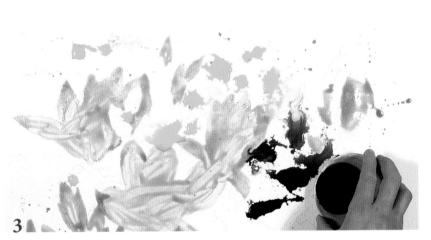

1 SKETCH THE COMPOSITION AND MASK THE FOCUS FLOWERS
Sketch the flowers and stems lightly with a no. 2 pencil. The three-line integration of this composition directs the viewer's eye in an arc-shaped movement. Block in the flowers at the focal point and the surrounding buds with masking fluid. (For more information on applying masking fluid, see page 24.)

2 WET THE PAINTING
When the masking fluid is dry, lightly wet the upper part of the painting using a spray bottle.

3 POUR THE PAINT
Pour the thinned Arylide Yellow first, Antwerp Blue second and Quinacridone Rose Red Deep last on the wet area. (For more information on pouring diluted paint, see page 22.) Each color should be next to the others but not overlapping. Spray a little more water on top for more blending.

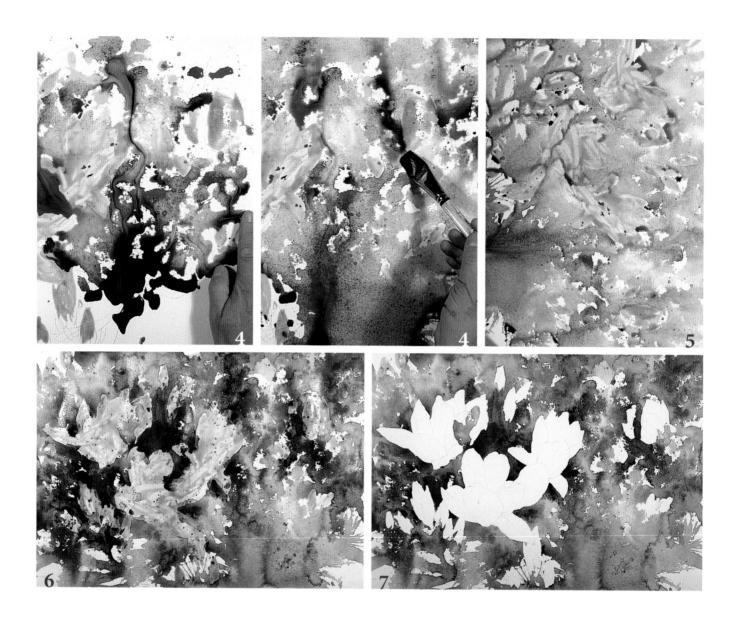

4 CONTINUE TO BLEND THE COLORS

To further blend the colors, use a 1-inch (25mm) flat brush and/or your fingers to guide them. However, don't mix them too much or the painting will become muddy.

5 TILT THE PAINTING

After pouring and blending paint over most of the painting, tilt the upper edge of the paining about 6 inches (15cm) higher than the lower edge. The colors will flow down and blend into each other beautifully.

6 ADD DEPTH WITH DARK PURPLE

Use the 1-inch (25mm) flat brush to mix Antwerp Blue and Quinacridone Rose Red Deep into a very dark purple to paint around the center of interest where the large, light-colored flowers are located. Apply the purple while the other colors are still wet so that they will blend. Also, apply the dark purple randomly throughout the middle-right and lower-left areas. Adding this dark color gives the whole painting more depth.

7 WAIT FOR THE PAINTING TO DRY AND REMOVE MASKING

Wait for the painting to dry completely before removing the masking. (See "Removing Masking" on page 24.)

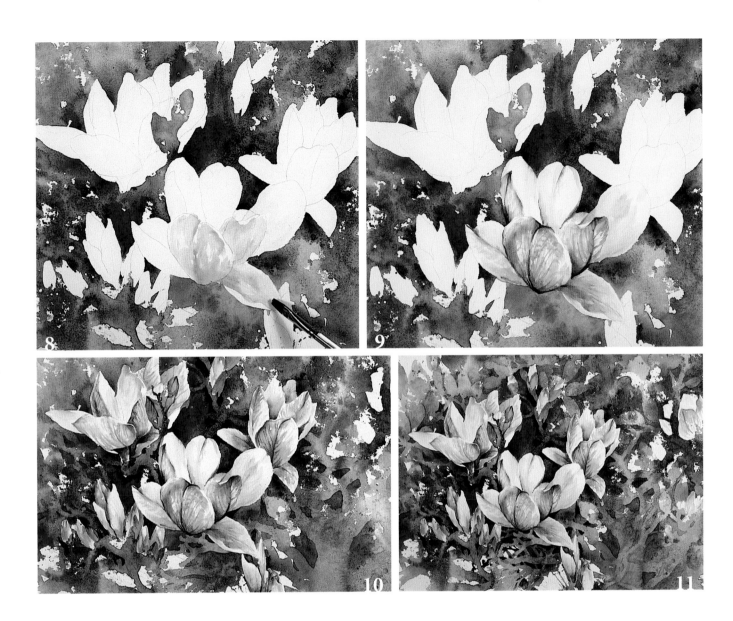

8 PAINT THE FOCAL-POINT FLOWER

To paint the central flower, use the ¾-inch (19mm) flat brush to lightly wet the base and middle of the petals. Use a no. 8 round brush to apply a little Arylide Yellow, then the Quinacridone Rose Red Deep on the bases. Wet the flat brush a little and use it to blend the colors toward the tips of the petals.

9 PAINT TEXTURE

When the colors are about halfway dry, use the no. 2 round brush to paint the texture on the center, base and tip with Quinacridone Rose Red Deep.

10 PAINT THE SEPAL

After the other blossoms have been painted, paint the sepal. Wet the no. 8 round brush slightly, then apply a little Arylide Yellow. Apply Antwerp Blue to the sepal's middle, dragging it toward the tip. At the tip, apply Quinacridone Rose Red Deep. Next, call out the trunk and branches using the negative painting technique: With the no. 8 round brush, paint Antwerp Blue around the objects. Then, immediately use the ¾-inch (19mm) flat brush to blend the paint into the background colors.

11 USE NEGATIVE PAINTING TO CALL OUT BUDS

Call out more buds from the background. Using the no. 2 round brush, paint around them with Antwerp Blue. The darker the background color, the darker the blue used (thick Antwerp Blue mixed with thick, soft Quinacridone Rose Red Deep makes a very dark color). Blend the pigment into the background with the slightly wet no. 8 round brush.

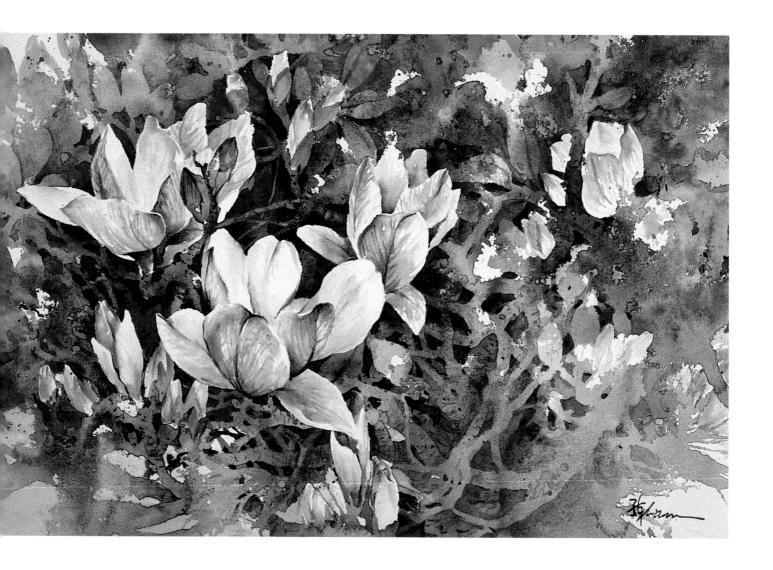

12 ADD FINISHING DETAILS

When the first layer of negative painting is dry, start defining more branches and buds behind with darker blue pigment. Define more layers and details near the focal point, while allowing the other areas to fade out. Stop the negative painting once the background color around the focal point reaches the darkest dark.

MAGNOLIA *watercolor on Arches 140-lb. (300gsm) cold-pressed watercolor paper 15" × 22" (38cm × 56cm)*

PEONY

The peony is one of the most popular floral subjects for Chinese paintings. In the iconography of Chinese culture, peonies connote prosperity, abundance and beauty. In this demonstration you'll try to capture the spirit of the flowers, but not their exact color or shape (i.e., as they would appear in a garden).

❀ MATERIALS

PAPER
single-layer raw Shuan paper, 14" × 18" (36cm × 46cm)

BRUSHES
small • medium • large

CHINESE PAINTS
Blue • Carmine • Indigo • Rouge • Vermilion • White • Yellow

OTHER SUPPLIES
Chinese ink

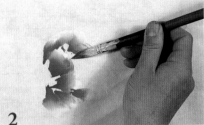

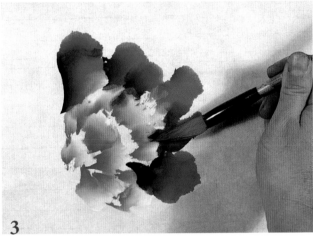

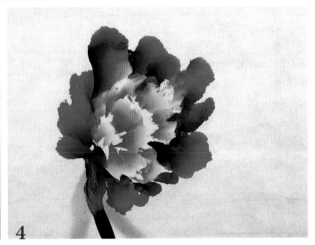

1 BLEND PIGMENTS ON BRUSH
Wet the large brush and load the heel to upper-middle section of the head with white and the lower middle and tip with Carmine. Dab the brush on the palette a few times to let the pigments gradually blend into each other.

2 PAINT THE INNER PETALS
Hold the brush sideways with the tip toward the center of the flower to paint the inner petals. Use one stroke to create each petal.

3 PAINT PETALS WITH LARGE BRUSH
Clean the large brush. Load the heel to the upper-middle section of the head with Carmine and the lower middle and tip with Rouge. Dip a little ink on the tip. Hold the brush sideways with the tip pointing toward the center of the flower. Paint the petals to the right of the inner petals.

4 COMPLETE OUTER PETALS
Reload the large brush with the same pigments, and a little water. Complete the outer-perimeter petals to the left of and below the inner petals. Always keep the brush tip pointing toward the center of the flower.

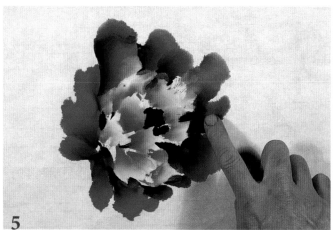

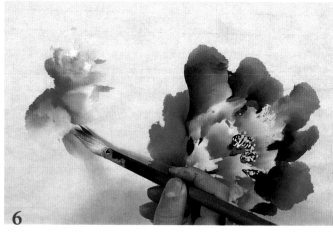

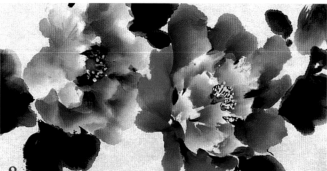

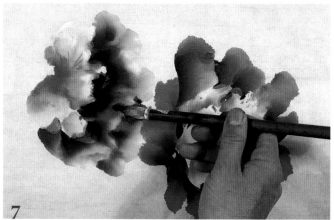

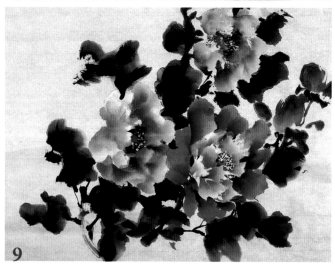

5 PAINT THE CENTER

Load the tip of the large brush with more Rouge and ink. Paint the center of the flower and add the dark red to the bases of the petals on the right. Gently use your finger to smear the dark red into the base colors so that they blend smoothly into each other.

6 PAINT THE LEFT FLOWER

To paint the peony blossom on the left, load a little yellow and a lot of white on the heel to upper middle of a large brush and Carmine at the lower middle and tip. Dab the brush on your palette to blend the colors. Hold the brush sideways to paint the front petals.

7 CONTINUE TO PAINT THE LEFT FLOWER

Load the heel of the brush with more yellow and white, the middle and tip with Rouge and the tip with ink. Hold the brush sideways to paint the other petals.

8 PAINT FLOWER CENTER DETAILS

Load the medium brush with blue and paint the centers of the flower. Load the small brush with a thick mixture of white and yellow to paint the stamens. Load the heel of a large brush with yellow and the middle with Indigo and the tip with ink. Hold the brush sideways to paint the leaves and the stems.

9 PAINT LEAVES AND BUDS

Continue to paint more leaves the same way. To achieve the light-colored leaves, load less of all three pigments on the brush. To paint the two buds, load the heel and middle of a large brush with Carmine and the tip with Rouge and ink. Hold the brush sideways to paint a couple of strokes for each bud.

10 ADD FINISHING DETAILS

Use the small brush to paint the veins of the leaves. For the dark-colored leaves, use Indigo and ink. For the light ones, use diluted Indigo and ink (mixing the pigments before you load them onto the brush). Sign and stamp the chop on the upper left to balance the composition.

PEONY *Chinese ink and color on single-layer raw Shuan paper 14" × 18" (36cm × 46cm)*

PEONY

In the previous Chinese painting demonstration you controlled the shape and colors of all the flowers. In this watercolor demonstration, you'll control only the flower you cover in masking fluid. The other flowers will emerge and "go with the flow." We'll create loose flower shapes by pouring diluted yellow and red paint. Then we'll use the negative painting technique to develop the flower shapes, following the suggestion of the blended paint.

✤ MATERIALS

PAPER

Arches 140-lb. (300gsm) cold-pressed watercolor paper, 15" × 22" (38cm × 56cm)

BRUSHES

nos. 2, 8 and 10 rounds • ¾-inch (19mm), 1-inch (25mm) and 1½-inch (38mm) flats

WATERCOLORS

Antwerp Blue (Winsor & Newton) • Azo Yellow Medium (Van Gogh) • Permanent Red Deep (Van Gogh)

OTHER SUPPLIES

no. 2 pencil • masking fluid • spray bottle • straw

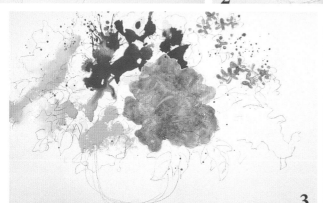

1 SKETCH THE COMPOSITION

Sketch the composition briefly with a no. 2 pencil. Apply the masking fluid on the flower in the central focal point and the chrysanthemums above. Splash the masking fluid on top of the painting to create small background flowers. Mix the three colors with water in three separate small dishes, creating medium-toned liquids.

2 WET PARTS OF THE PAINTING

Use the 1½-inch (38mm) flat brush to wet the petals of the two flowers next to the central flower, randomly leaving dry areas, which will become highlights. (For demonstration purposes, I added a little Permanent Red Deep to the water so that you can see where I've applied the water. You should use clear water.) Next use the spray bottle to lightly wet the upper left quarter of the painting.

3 POUR THE COLORS

Pour the thinned Azo Yellow Medium first and the Permanent Red Deep second on the wet areas of the flower. The colors should blend where they meet.

4 POUR AND BLEND BLUE

Pour the thinned Antwerp Blue on the upper left and lower-middle left where the leaves should be located. The colors will run into each other and flow down to the vase area. Use a finger and brush to guide the blending and flowing. Blow the colors on the upper left directly or blow through a straw to create the foliage in the distance. Don't paint details.

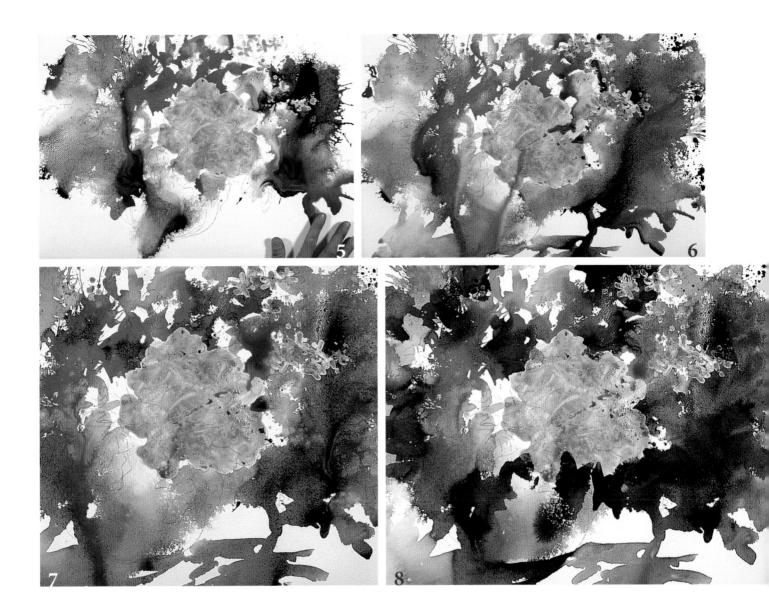

5 POUR PAINT ON RIGHT SIDE
While the colors continue to blend on the left side, wet and pour the paint on the right side of the painting in a similar way.

6 TILT THE PAINTING
Tilt the upper-right corner of the painting up about 6 inches (15cm) to let the color flow from the upper right toward the lower left. This will remove excess liquid (it will drip off the paper) and will blend the colors beautifully. In the lower-middle portion of the painting use a 1½-inch (38mm) flat brush to direct the flow of the liquids so they create shadows.

7 SPLASH COLOR ON PAINTING
When the colors are about 70 percent dry, use the flat brushes (one brush for each thinned color) to splash the paint on the painting. This creates the colorful illusion of flowers.

8 GIVE DEPTH TO THE PAINTING
Using the 1½-inch (38mm) flat brush, mix undiluted Antwerp Blue with a little undiluted Permanent Red Deep to create a dark purple. Apply this mixture around the flowers. Lightly wet another flat brush and drag the dark purple, lightening it and blending it into the background colors. This gives depth and a variety of values to the painting. Also, use the dark purple to define the vase.

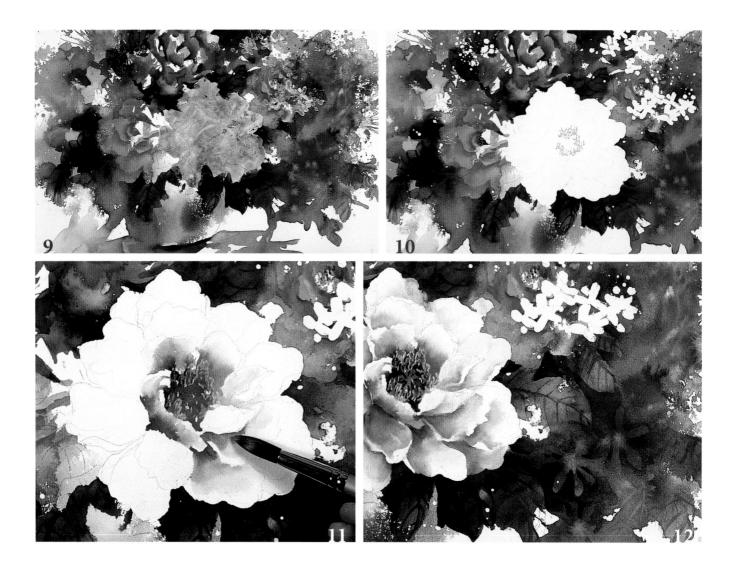

9 PAINT THE EXTRA FLOWERS

Use the nos. 8 and 10 round brushes to define the three flowers around the peony in the focal point. Use the no. 8 to apply color, and the no. 10 to blend. At the bases of petals, apply the background colors mixed with a little blue to make them darker. Then blend them to the center of the petals and fade out into the background colors at the tips of the petals. To call out the leaves, use the no. 2 round brush to paint the veins with the leaf colors mixed with a little blue to make them darker.

10 REMOVE THE MASKING

When the painting dries completely, take off the masking. Now you can see the shapes of the main flower, the chrysanthemums and the little flowers. Block in the stamens of the peony with masking fluid so that you can paint its petals freely.

11 PAINT THE CENTRAL PEONY

Use two round brushes to paint this flower: the no. 8 for applying colors and the no. 10 for blending. At each petal paint the base with Permanent Red Deep and a little Antwerp Blue. Then lightly wet the no. 10 round brush and use it to drag the upper edge of the colors toward the center of the petal. Leave white at the tip. The colors of each petal gradually change from a darker value at the base, to a lighter one in the middle, to paper-white at the tip.

12 DEFINE OBJECTS IN BLUE

Next, define the leaves and flower on the right side of the central peony. Use the no. 10 round brush to paint around the objects with Antwerp Blue. Use the 1½-inch (38mm) flat brush to blend the paint away from the objects so that it gradually fades out into the background colors. The darker the value of the base colors (the colors poured in Step 3), the darker the Antwerp Blue should be to define the objects. To achieve a dark blue, dilute the paint less and add a little Permanent Red Deep.

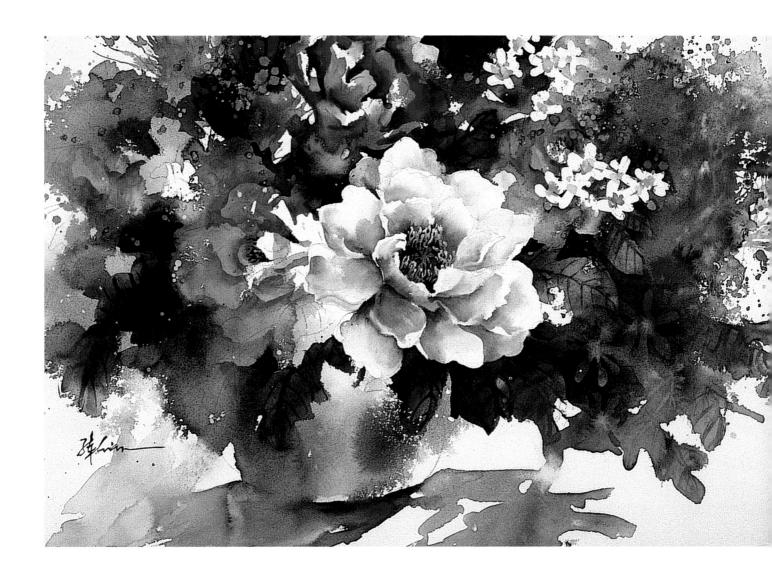

13 REMOVE MASKING, ADD FINISHING DETAILS

When the petals are dry, remove the masking from the stamens. Use the no. 2 round brush to apply Azo Yellow Medium to the stamens. When it is about 50 percent dry, add a little Permanent Red Deep at the bottom of each stamen. The two colors should blend where they meet. Fill in the little white spots with Antwerp Blue. Finally, paint the stamens of the chrysanthemums with Azo Yellow Medium and Permanent Red Deep.

PEONY *watercolor on Arches 140-lb. (300gsm) cold-pressed watercolor paper* *15" × 22" (38cm × 56cm)*

ORCHID

In this demonstration you'll learn to use minimum strokes to achieve maximum effect. Each brushstroke counts in depicting the flowers. If you make one or two wrong strokes, you should throw away the painting (I prefer to call it the paper) and start again.

✿ MATERIALS

PAPER
single-layer raw Shuan paper, 14" × 20" (36cm × 51cm)

BRUSHES
small • medium • large

CHINESE PAINTS
Carmine • Indigo • Phthalo Blue • Rouge • Vermilion • White • Yellow

OTHER SUPPLIES
Chinese ink

1 PAINT THE CENTER OF THE LABELLUM
Load the heel of a large brush with yellow, then the middle with Carmine and the tip with Rouge. Dip the tip into a little ink, and hold the brush sideways, painting several strokes to create the center of the labellum.

2 PAINT THE CENTER AND ADD TEXTURE
Immediately, use the small brush to paint thick, soft yellow pigment in the center to add texture.

3 PAINT THE LABELLUM POUCH
Load the heel of a medium brush with white, the middle with yellow and the tip with Phthalo Blue. Dab the brush on the palette several times to let the colors blend. Hold the brush sideways with the tip facing away from the center of the labellum. Paint two strokes forming the corn-shaped pouch of the labellum. Immediately use the small brush with Rouge to paint the texture in the reddish area.

4 POUR AND BLEND BLUE
Load the large brush with white, yellow, Carmine and Phthalo Blue from the heel to the tip. Hold it sideways with the tip pointing toward the center of the flower. Paint each of the petals and sepals with one stroke. Immediately use the medium brush to call out the centers of the petals with thick, soft white pigment.

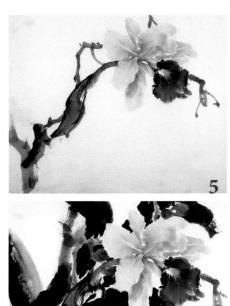

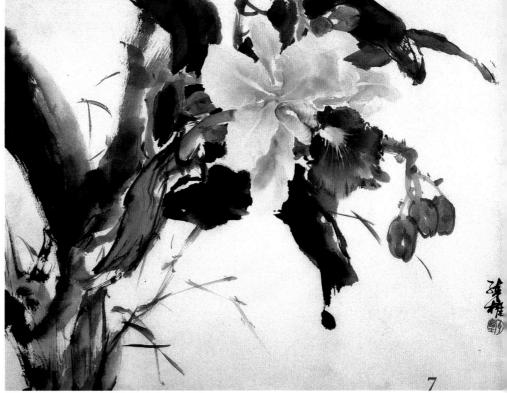

5 PAINT THE STEMS

Use the large brush to mix yellow, Carmine and a little ink into a brownish color. Dip the tip of the brush into ink. Hold it sideways to paint the large stems. Use the medium brush to mix yellow, Phthalo Blue and a little Carmine into an orangey green. Hold the brush straight to paint the smaller stems, then load a little ink on the tip to paint the texture on the larger stems.

6 PAINT THE BUDS AND LEAVES

Load the entire head of the medium brush with yellow, the middle to the tip with Phthalo Blue and the tip with Vermilion. Hold the brush sideways to paint the buds (two strokes for each bud). Wet the large brush and load the entire head with yellow, then the upper middle with ink. Dip the tip and middle of the brush into the ink. Hold it sideways to paint the leaves.

7 FINISHING TOUCHES

Finally, use the medium brush to mix a little yellow, Vermilion and light ink (for more information on achieving different shades of ink, see page 12) with a very small amount of water. Paint the grasses with minimum strokes and a swift motion.

ORCHID *Chinese ink and color on single-layer raw Shuan paper*
　　　　 14″ × 20″ (36cm × 51cm)

ORCHID

In this demonstration you'll learn to combine the detail style and spontaneous style in one painting. You'll paint the objects in the background loosely, but you'll depict the focal-point flowers and the objects near them with great detail. Some of my students define all the objects in their paintings with the same level of detail. I call this uneconomical production: The more labor you put in, the less money you earn. Such paintings lack breathing room for the viewer and, therefore, don't tend to sell well.

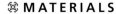

❈ MATERIALS

PAPER

Arches 140-lb. (300gsm) cold-pressed watercolor paper, 15" × 22" (38cm × 56cm)

BRUSHES

nos. 2, 4, 8 and 10 rounds • ¼-inch (6mm), ½-inch (13mm), ¾-inch (19mm) and 1-inch (25mm) flats

WATERCOLORS

Antwerp Blue (Winsor & Newton) • Azo Yellow Medium (Van Gogh) • Permanent Red Deep (Van Gogh)

OTHER SUPPLIES

no. 2 pencil • masking fluid • spray bottle • table salt • straw • paper towels

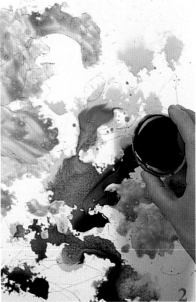

1 SKETCH THE COMPOSITION, APPLY MASKING FLUID

Sketch the composition lightly with a no. 2 pencil. Apply the masking fluid on the orchid flowers at the focal point. Dilute the three colors with water to create thin, medium-toned mixtures in three separate small dishes.

2 POUR BLUE AND YELLOW PAINT

Start painting when the masking is dry. Spray water lightly on the area around the focal-point flowers. Pour the thinned Azo Yellow Medium first, then the Antwerp Blue next to it. Spray a little more water on the colors so they blend more.

3 POUR RED PAINT

Pour the thinned red paint on the upper right and around the flowers. Now pour all three colors on the middle part of the painting. Spray a little water to facilitate blending. Tilt the upper-left corner of the painting up about 6 inches (15cm) to let the liquids flow down toward the bottom right. This will create the vines in a random fashion. You can also use a brush or your fingers to direct the flow while creating the vines.

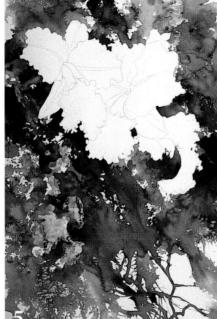

4 ADD DETAILS

Lay the painting flat. While the paint is still wet, use the 1-inch (25mm) flat brush to mix undiluted blue with a little red to create a very dark blue. Paint the dark blue next to the flowers and other parts of the painting to provide value contrast. Use the ¾-inch (19mm) flat brush to splash thinned yellow paint on the painting. (Yellow-green will be the dominant color in this painting.) Drop about twenty grains of table salt at the bottom left and middle right to create an abstract background. The salt dissolves in the watercolor and pushes the color away, creating the illusion of rain or snow.

5 REMOVE MASKING ON LARGE ORCHIDS, SKETCH FLOWERS

When the paint is completely dry, remove the masking from the large orchid flowers (leave the masking on the smaller flowers). Use a no. 2 pencil to lightly sketch the details of shape and texture on the focal-point flowers.

6 WET AND PAINT CENTER OF LABELLUM

Use the no. 8 round brush to wet the center parts of the labellum. Immediately use the no. 4 round brush to apply undiluted yellow pigment to the wet area.

7 BLOW TEXTURE ONTO PAINTING

Next, use the no. 4 round brush to apply red in the upper and lower parts of the yellow on the labellum. To create the texture of the labellum, blow through a straw or directly onto the painting to push the red into the lower parts of the labellum. Then use the no. 10 round brush to paint some blue and red on the lower part of the labellum. The colors will mix on the paper.

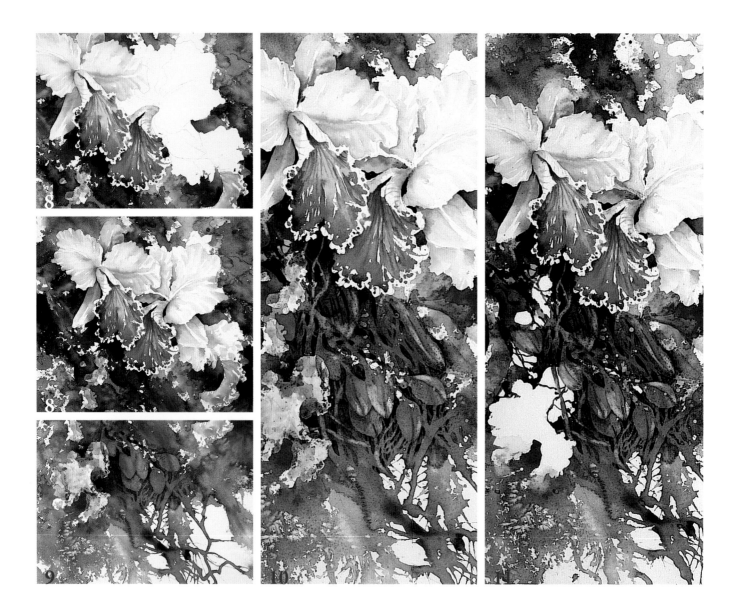

8 CONTINUE ADDING COLOR TO FLOWERS

Use the ½-inch (13mm) flat brush to wet the bases of the petals and sepals. Use the no. 10 round brush to paint light blue and light red on the wet areas. Immediately use the 1-inch (25mm) flat brush to blend the colors into the middle and tips of the petals. Lightly wet the pouches of the labellum. Apply light yellow and light red with a ½-inch (13mm) flat brush, leaving some whites. Then use the no. 2 round brush to add texture to the pouches with red pigment.

9 USE NEGATIVE PAINTING TO DEFINE FLOWERS

Define the flower buds, leaves and vines. Use a no. 8 round to apply color and a no. 10 to blend. To call out the buds, use one brush to mix blue with a little red into a darker blue than the background color. Paint this mixture around the buds. Lightly wet the other brush to blend the dark blue into the background. The buds will be lighter than the colors around it (for more on negative painting see page 25).

10 DEFINE MORE ELEMENTS

Using the same negative painting technique you used to define the buds, continue to define more leaves, vines and stems. In the darker area, where you can't use the negative painting technique but want to call out the objects, use a damp ¼-inch (6mm) flat brush to lift the colors. The lines between and under the colorful labella are defined in this way.

11 REMOVE REMAINING MASKING

Lift the rest of the masking. Use the no. 2 and no. 4 rounds to paint the vines over the smaller orchid flowers. Now these flowers are pushed behind the vines. Use a wet paper towel to scratch away some of the color at the bottom edges of the flower on the lower left.

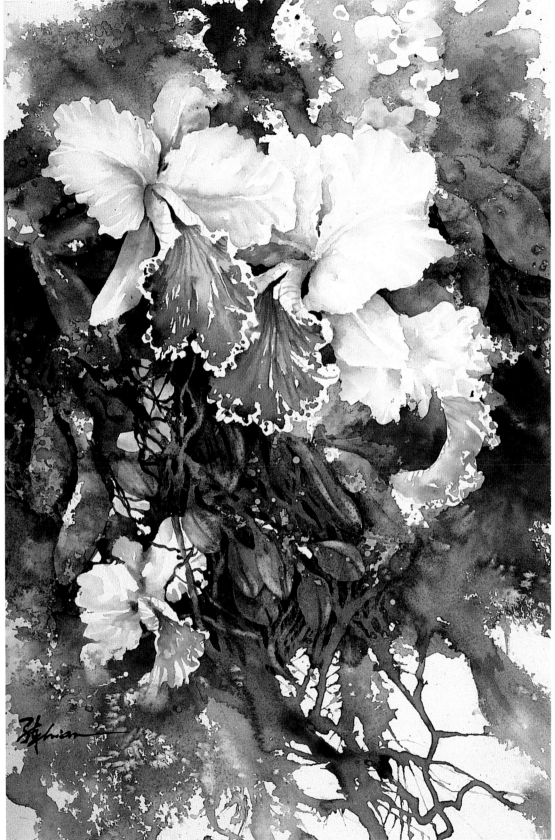

12 FINISHING FLOWER DETAILS

Paint the background flowers in the same manner as the larger ones, but with less detail and lighter colors because they are in the background. Use yellow and blue and a no. 2 round brush to fill in the small white dots created by masking and pouring. These dots are similar to the happy dots in Chinese painting: They create highlights and energy flow in the painting.

ORCHID *watercolor on Arches 140-lb. (300gsm) cold-pressed watercolor paper 15" × 22" (38cm × 56cm)*

COCONUT TREE

Most spontaneous-style paintings are created with the no-bone method, but in this demonstration you'll use the bone method (see page 12) to outline the coconut with ink before applying colors. You'll also learn how to split the brush tip with your fingers and use the split tip to paint hairy texture.

✿ MATERIALS

PAPER
single-layer raw Shuan paper, 14" × 20" (36cm × 51cm)

BRUSHES
medium • large

CHINESE PAINTS
Burnt Sienna • Carmine • Indigo • Vermilion • White • Yellow

OTHER SUPPLIES
Chinese ink

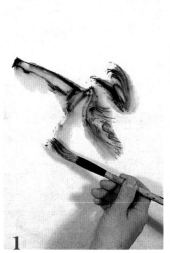
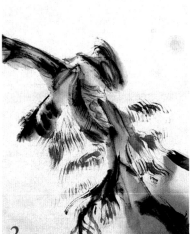
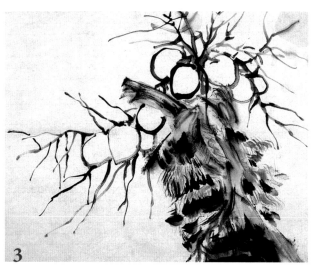

1 *Mix Colors and Paint Stems*
Use a large brush to mix a little white, Carmine and Burn Sienna. Holding the brush sideways, paint four strokes to depict the broken stems of the leaves. Now the brush head should be free of water and color, and the brush tip should be split open. (If the tip doesn't split naturally, use your fingers to split it.) Apply a small amount of ink to the split tip, and hold the brush straight to paint the textures.

2 *Paint the Silks*
Use a large brush to mix Burnt Sienna with a little ink. Split its tip into many sections (like a comb) with your fingers and paint the silks.

3 *Paint the Trunk, Coconuts*
After you've painted the silks, don't clean the brush. Instead, load it with ink and paint the trunk. Wet a medium brush and dip the tip of it into the ink. Hold it perpendicular to the painting to paint the coconuts. Also, mix Burnt Sienna and Carmine and paint the lighter-colored stems of the coconuts with a medium brush. Clean the brush, then load ink on the tip of it to paint the darker stems.

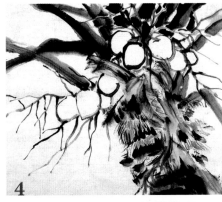

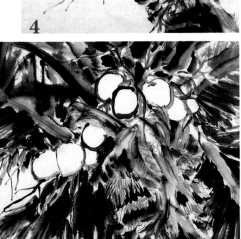

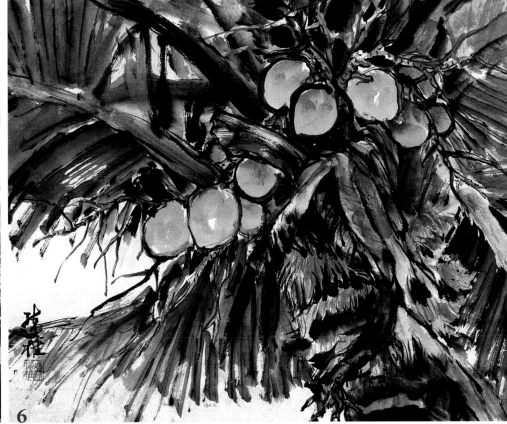

4 PAINT LEAF STEMS

Load the entire head of a large brush with Burnt Sienna, and the tip to the lower-middle section of the head with ink. Hold the brush slightly sideways to paint the stems of the leaves.

5 PAINT THE LEAVES

Next, load the heel of a large brush with yellow and Burnt Sienna, the middle and tip with Indigo. Dip the tip of the brush into the ink. Hold the brush slightly sideways to paint the leaves. Wait a few minutes until the colors are about 70 percent dry. Using a medium brush, paint ink strokes on the leaves to define them.

6 FILL IN COCONUTS

Load the entire head of a large brush with yellow, the heel with a small amount of Indigo, the center with a small amount of Vermilion, and the tip and lower-middle section with Burnt Sienna. Hold the brush sideways, with the tip on the pointed tip of each coconut. Paint two strokes for each nut. Leave some white to suggest highlights.

COCONUT TREE *Chinese ink and color on single-layer raw Shuan paper*
14" × 20" (36cm × 51cm)

BANANA TREE

Artists occasionally sketch on raw Shuan paper before painting. Here's an example of how to use light and medium-toned ink to roughly sketch the images of a banana flower, a banana and a banana tree before applying colors.

✿ MATERIALS

PAPER
single-layer raw Shuan paper, 20" × 14" (51cm × 36cm)

BRUSHES
small • medium • large

CHINESE PAINTS
Blue • Carmine • Indigo • Phthalo Blue • Rouge • Vermilion • Yellow

OTHER SUPPLIES
Chinese ink

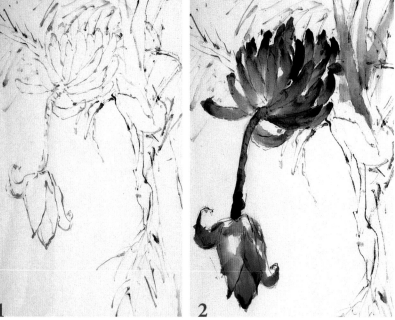

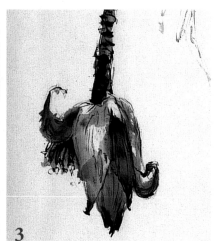

1 SKETCH THE BANANA TREE
Dilute the ink with water, creating a medium tone. With a small brush, use a little of the medium-toned ink to sketch the banana tree.

2 PAINT THE FLOWER
Wet a large brush and load the heel with yellow, the middle with Carmine and the tip with Rouge. Dip the tip lightly into the ink. To paint the flower, hold the brush sideways, pointing the tip toward the tips of the flower petals. Load the entire head of a medium brush with yellow, the middle with Phthalo Blue and the tip with Carmine and ink. Paint each banana in one stroke, holding the brush sideways and aligning the tip with the end of the banana. Next, load the same colors in the same manner, but hold the brush straight (perpendicular to the painting) to paint one stroke for the stem that connects the flower and the bananas.

3 PAINT THE FLOWER TEXTURE
Using a small brush, lightly mix Rouge and ink on the palette. Paint the texture of the flower. Load the brush with more ink, then outline the bananas and paint the textures of the stem.

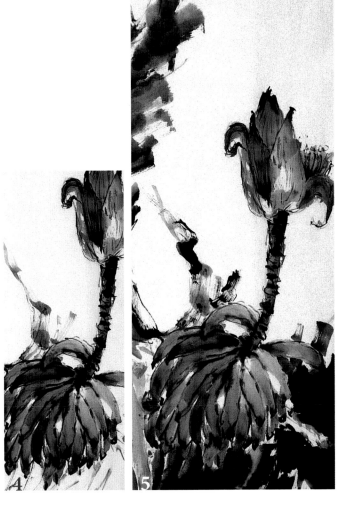
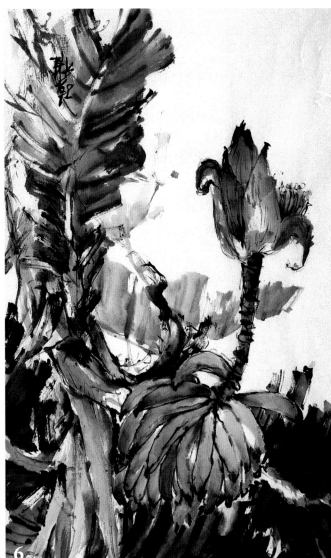

4 PAINT THE BANANAS, STEMS, LEAVES

While the colors are still wet, use a medium brush and add blue to highlight the tips of several bananas. Load the entire head of a large brush with yellow, then load its middle with a small amount of blue and Vermilion, and its middle and tip with Carmine. Hold the brush sideways to paint the stems of the leaves on the right. Load a large brush with yellow, then load it from middle to tip with blue and Vermilion. Hold the brush straight to paint the stems of the leaves in the upper right.

5 PAINT THE OTHER LEAVES

Load the entire head of a large brush with yellow. Add a small amount of blue and Vermilion to the middle, and Carmine and ink to the tip. Hold the brush sideways to paint the leaf on the right. Load a large brush with Indigo, then load it from middle to tip with ink. Hold it sideways to paint the other leaves.

6 ADD FINISHING DETAILS

Finally, load a large brush with yellow, then load its middle and tip with a little blue and Vermilion, and its tip with Carmine. Hold it sideways to paint the two leaves in the background. Immediately, load the tip with a little light (diluted) ink to paint the texture of the leaves.

BANANA TREE *Chinese ink and color on single-layer raw Shuan paper*
20" × 14" (51cm × 36cm)

ROSE

In this demonstration you'll learn a new method for painting flower petals. First you'll paint the foundation colors of the entire flower, then you'll immediately use thick, barely diluted white to call out the petals from the foundation colors. This technique is commonly used by Lingnan School artists, a relatively new Chinese painting school founded approximately 110 years ago. It is popular in southern China, Hong Kong and Taiwan, as well as among Chinese communities abroad.

✿ MATERIALS

PAPER
single-layer raw Shuan paper, 14" × 20" (36cm × 51cm)

BRUSHES
small • medium • large

CHINESE PAINTS
Carmine • Phthalo Blue • Rouge • White • Yellow

OTHER SUPPLIES
Chinese ink

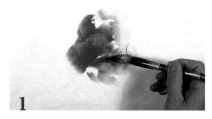
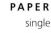
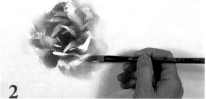
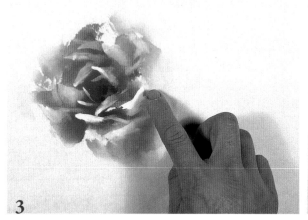
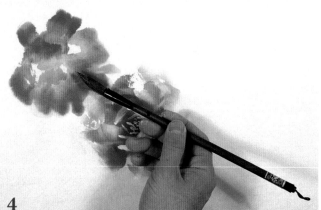

1 SOAK BRUSH, PAINT PETALS
Load the back to middle part of a large brush with white, then load the middle to the tip with Carmine, and the tip with Rouge. Hold the brush sideways with the tip toward the center of the flower. Paint several strokes to create petals.

2 HIGHLIGHT PETALS
Lightly wet a large brush. Load it from the middle to the tip with thick white. Hold it sideways to highlight the petals. Use one stroke per petal.

3 USE YOUR FINGERS TO SMEAR WHITE PIGMENT
For smoother blending, immediately use your fingers to smear the undiluted white pigment into the background colors.

4 PAINT BASE OF OTHER ROSE
Soak a large brush and load the entire head with yellow. Then load the middle to the tip with Carmine. Dab the brush on the palette to blend the pigments. Hold the brush sideways to paint several strokes, creating the base color of the other rose.

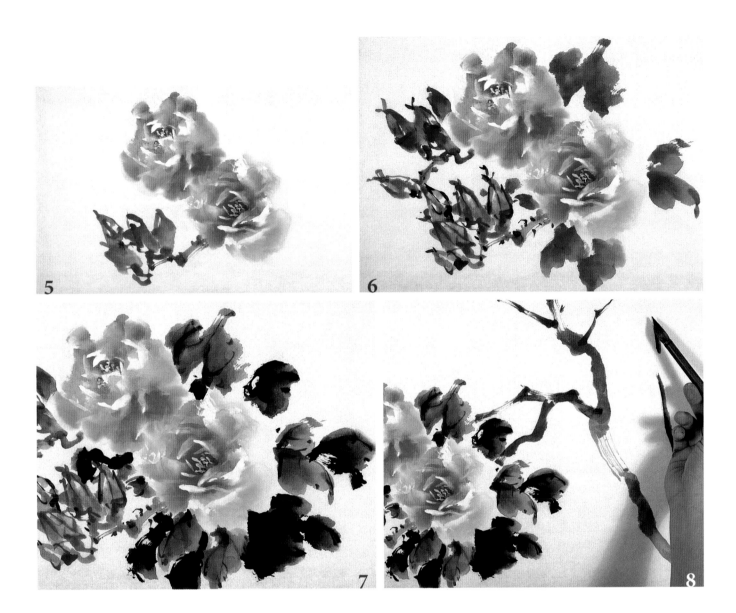

5 BLEND, PAINT BUDS AND STEMS

Wet a large brush lightly and load the middle to the tip of the brush head with thick white. Hold it sideways to call out the petals, forming the shapes through highlights. Also, use your fingers to blend the white pigment into the base colors. Load the back of a medium brush head with Phthalo Blue, then load the back to the tip with yellow, the middle to the tip with Carmine and the tip with Rouge. Hold the brush slightly sideways to paint the buds and stems.

6 ADD DETAILS

Paint more buds and stems in the same manner. To highlight the tips of the buds, wet a medium brush and load from the middle to tip of the brush head with white and then Carmine. Dab the brush to blend the colors, then paint one stroke on each bud. Wet a large brush and load the back to middle of the head with Phthalo Blue, the middle with a little yellow and the middle to tip with Carmine. Hold the brush sideways to paint the young leaves around the roses.

7 PAINT THE DARKER LEAVES

Wet a large brush and load the back to middle of the brush head with Phthalo Blue and the middle to tip with ink. Hold the brush sideways to paint the darker leaves. While the colors on the leaves are still wet, use a small brush to call out their veins with ink.

8 PAINT THE STEMS

To paint the stems, lightly wet a large brush, then load the entire head with Carmine. Then load middle of the head to the tip with ink. Hold the brush straight (perpendicular to the painting) to paint the large stem first. Load the tip and middle of the brush head with more Carmine, and paint the smaller stems.

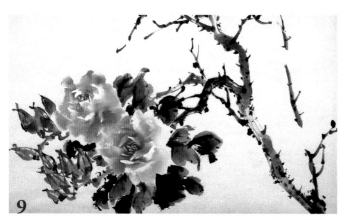

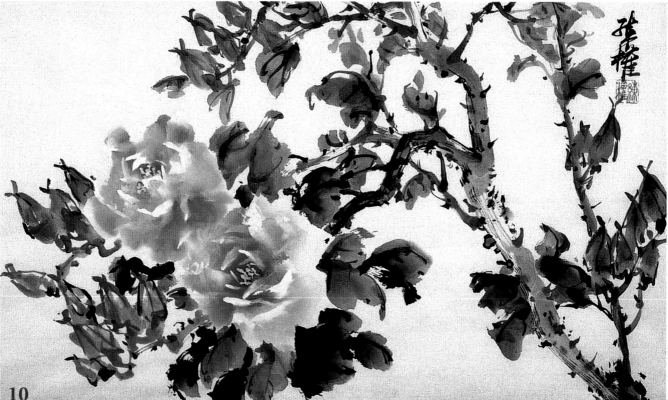

9 PAINT THE THORNS, LARGE STEM

Load a medium brush with a little ink and Carmine. Hold the brush straight to paint the thorns. (The thorns facing you look like dots.) Split the tip of the brush with your fingers. Dip the split brush into a little ink and paint the texture on the lower part of the large stem.

10 ADD FINISHING DETAILS

Continue adding more leaves and buds as shown in Steps 6 and 7. Sign and stamp the upper left to balance the composition.

ROSE *Chinese ink and color on single-layer raw Shuan paper 14″ × 20″ (36cm × 51cm)*

ROSE

In the previous rose demonstration you learned how to paint a flower by applying its base colors first. Now you'll apply this method to a watercolor painting of the same flower. You won't use masking fluid in this painting. Instead, you'll pour the diluted yellow and red on the paper and guide their blending to create the colors and loose shapes of roses. Finally you'll use the negative painting technique to call out the shapes of the flower, stems and leaves.

✤ MATERIALS

PAPER
Arches 140-lb. (300gsm) cold-pressed watercolor paper, 15" × 22" (38cm × 56cm)

BRUSHES
no. 10 round • ¾-inch (19mm) and 1-inch (25mm) flats

WATERCOLORS
Antwerp Blue (Winsor & Newton) • Arylide Yellow (Da Vinci) • Naphthol Red Mid-Tone (Da Vinci)

OTHER SUPPLIES
spray bottle

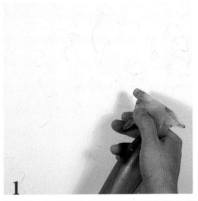

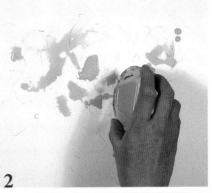

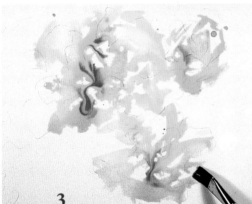

1 ORGANIZE THE COMPOSITION
Organize the composition roughly in your mind without sketching: You are going to paint several roses as a focal point in the upper right portion of the painting, with yellowish flowers in front and reddish ones behind. Also, the stems will grow from the lower left to upper right. Dilute the three pigments in three separate small dishes, creating medium-toned mixtures. Use a spray bottle to wet the focal point area slightly.

2 POUR THE YELLOW PAINT
Pour the yellow paint onto the area you've designated for the yellowish roses.

3 DROP RED PAINT ONTO YELLOW
Use the 1-inch (25mm) flat brush to drip some red paint onto the yellow area. The colors will start to blend. Use the same brush to guide the flow. Leave some whites on the flowers.

4 POUR THE RED PAINT
Pour the red paint on the upper-left area of the yellow roses. Let the color blend into the yellow flower a little.

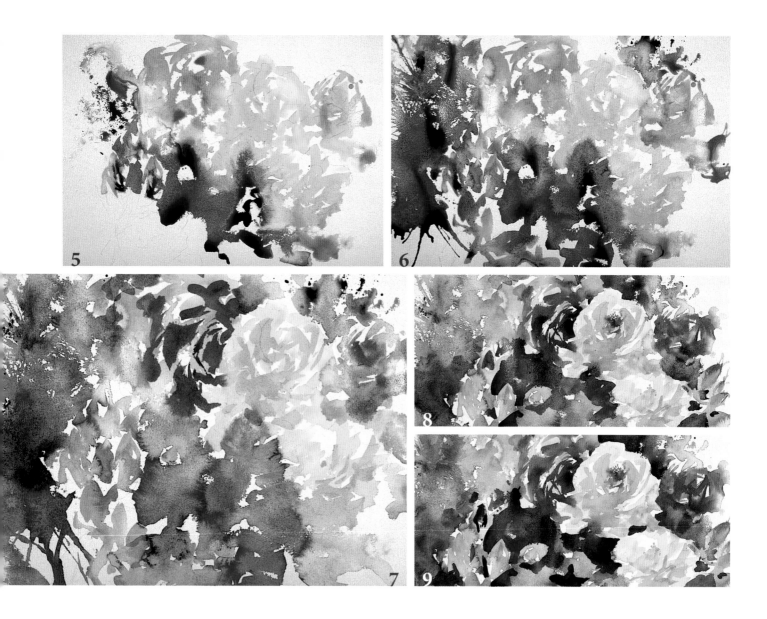

5 POUR THE BLUE PAINT

Pour the blue paint to the left of the yellow and red, where the leaves will go.

6 BLOW THE PAINT

Next use the ¾-inch (19mm) flat brush to paint the buds in the lower left and middle right with the thinned yellow and red paint. Pour more blue and red on the upper left and yellow on the lower left. Blow the paints on the upper left toward the corner to create the illusion of distant flowers.

7 DEFINE THE ROSES

When the focal-point flowers are almost dry, begin defining the petals. Use the ¾-inch (19mm) flat brush to paint the petals of the yellow roses with thick, barely diluted yellow. Then lightly wet the 1-inch (25mm) flat brush and use it to blend the thick yellow into the yellow petals. Using red pigment, follow the same procedure to define the red roses.

8 DEFINE THE FLOWER EDGES

Use the 1-inch (25mm) flat brush to mix thick blue and a little thick red into a dark blue. Define the edges of the flowers and the buds, as well as the stems at the lower left, using the negative painting technique. Use the no. 10 round brush to paint the center of the yellow rose with red and yellow, and the center of the red rose with red and blue.

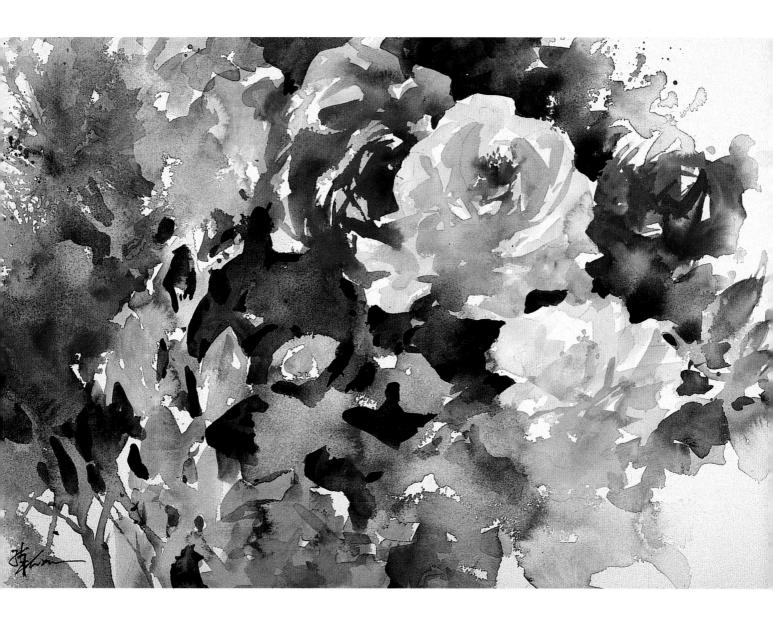

9 Add Finishing Details

When the colors are about 80 percent dry, use the ¾-inch (19mm) flat brush to mix thick blue and thick red into a very dark blue. Using the negative painting technique, define more leaves in the center next to the focal-point flowers.

ROSE *watercolor on Arches 140-lb. (300gsm) cold-pressed watercolor paper*
 15" × 22" (38cm × 56cm)

WATER LILY

The flowers in spontaneous-style Chinese paintings tend to be suggested through color, shape and texture rather than through realistic depiction. In this painting of water lilies, you won't attempt to define each petal. Instead, you'll depict the entire flower with minimal strokes. Also, rather than painting the water itself, you'll paint the small plants and weeds growing from the water to suggest its presence.

✿ MATERIALS

PAPER
single-layer raw Shuan paper, 14" × 18" (36cm × 46cm)

BRUSHES
small • medium • large • extra large

CHINESE PAINTS
Indigo • Rouge • Scarlet • Vermilion • Yellow

OTHER SUPPLIES
Chinese ink

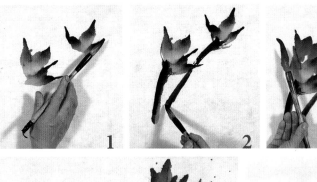

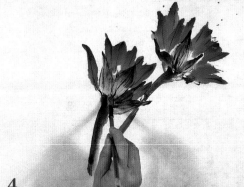

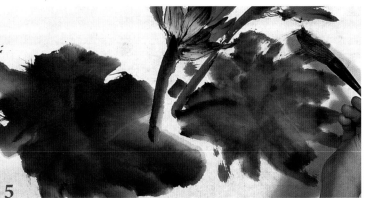

1 PAINT THE SEPALS
Wet a large brush and load the heel with yellow, the middle with Scarlet and the tip with Rouge. Dip the tip into a little ink. Hold the brush sideways to paint the sepals, one stroke per sepal.

2 PAINT THE STEMS
Rewet the brush and load the same colors again but with more ink at the tip. Hold the brush slightly sideways to paint the stems.

3 PAINT THE PETALS
Rinse the brush to clean it. Load the heel to middle with Scarlet and the tip with Rouge. Hold the brush sideways to paint the petals, one stroke per petal.

4 PAINT TEXTURE
Slightly wet a medium brush and split the tip with your fingers. Paint the texture of the sepals with a mixture of Rouge and ink. Use a small brush to call out the center of each petal with the Rouge and ink mixture.

5 PAINT THE LILY PADS
Wet an extra-large brush and load the entire brush head with Indigo, then the lower middle to the tip with ink. Hold the brush sideways to paint the lily pad on the left, moving from the center out. Load the brush again with the same colors, but add a little Rouge to the middle and tip. Paint the lily pad on the right.

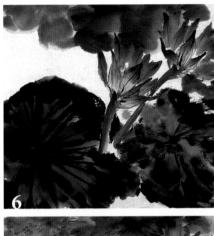

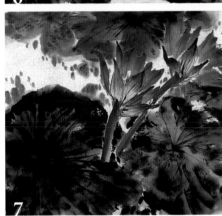

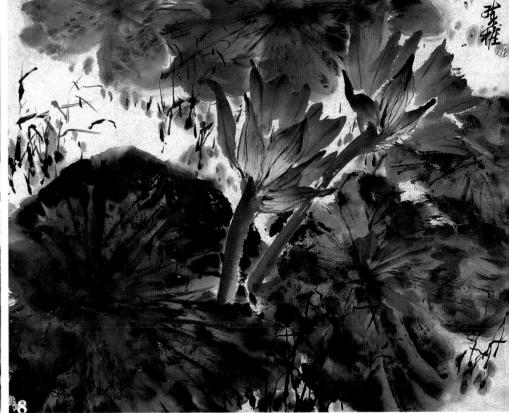

6 FINISH THE LILY PADS

Use the brush to paint the other lily pads the same way. Wait until the pads are about 60 percent dry. Load the brush with ink to paint the texture on the pads. For the pad on the upper left, use lighter (diluted) ink.

7 PAINT SMALL PLANTS ON WATER

Next, load the entire head of a medium brush with Indigo, then the middle to tip with Scarlet and the tip with ink. Hold the brush sideways to paint the small plants on the water.

8 ADD FINISHING DETAILS

Load the medium brush with ink to paint the grasses. Sign and place your chop on the upper right to finish the painting.

WATER LILY *Chinese ink and color on single-layer raw Shuan paper*
14" × 18" (36cm × 46cm)

WATER LILY

Similar to the Chinese painting demonstration of the water lily, in this watercolor demonstration you'll suggest the flowers with minimum details. Some petal tips will be defined with left-whites rather than colors. You'll also learn a new approach to floral painting: First, you'll paint the flowers and bud, then you'll pour the diluted pigments to paint the water, lily pads, weeds and reflections.

❈ MATERIALS

PAPER
Arches 140-lb. (300gsm) cold-pressed watercolor paper, 22" × 15" (56cm × 38cm)

BRUSHES
nos. 4 and 10 rounds • ½-inch (13mm), ¾-inch (19mm) and 1-inch (25mm) flats

WATERCOLORS
Antwerp Blue (Winsor & Newton) • Arylide Yellow (Da Vinci) • Naphthol Red Mid-Tone (Da Vinci)

OTHER SUPPLIES
no. 2 pencil • spray bottle • paper towels

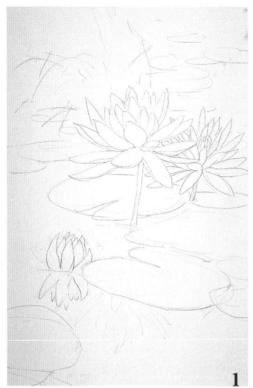

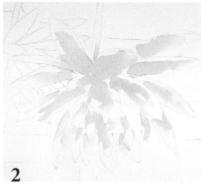

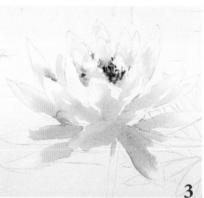

1 SKETCH THE COMPOSITION
Lightly sketch the composition on the watercolor paper with a no. 2 pencil. Dilute the three pigments with water in three separate small dishes to create medium-toned color mixtures.

2 BEGIN PAINTING THE PETALS
Use the ¾-inch (19mm) flat brush to lightly wet the petals of the foreground flower, leaving the tips dry. Immediately use the ½-inch (13mm) flat brush to paint thinned yellow on the bases. Use the ¾-inch (19mm) flat brush to blend the yellow into the upper-middle portion of the petals.

3 ADD RED PAINT TO BASE OF PETALS
When the yellow is about 50 percent dry, add a little thinned red to the petal bases. Use the no. 4 round brush to paint the stamens with a mixture of undiluted red and blue.

4 PAINT THE RED PETALS
When the petals are almost dry, use the ½-inch (13mm) flat brush to paint a little blue on the bases, blending it into the middle. Next, wet the petals of the background flower with the ¾-inch (19mm) flat brush. Use the ½-inch (13mm) flat brush to paint the base and middle sections of the petals with undiluted red from the palette.

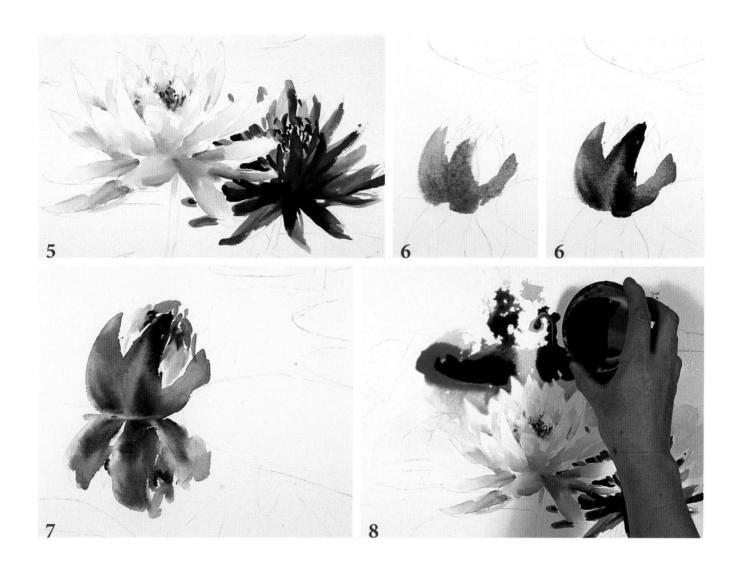

5 PAINT SHADOWED AREAS

Immediately, use the ½-inch (13mm) flat brush to mix thick red and a little thick blue into a darker red. Use this mixture to paint the petals in the shadow areas, as well as the stamens. While the stamen colors are wet, use the no. 10 round brush to add a few strokes of yellow that has been diluted to a medium tone.

6 PAINT THE BUD

Next, use the no. 10 round brush to wet the bud lightly. Use this brush to paint the bud with medium-toned yellow, then add medium-toned blue at the base and red at the tip. While the colors are still wet, mix thick blue with thick red into a dark blue to paint the center of the bud.

7 FINISH BUD AND REFLECTION

Continue to paint the red petals of the bud using the no. 10 round brush. First paint them yellow, then red and then the dark blue. When you're finished painting the bud, paint its reflection in the same manner but more loosely.

8 PAINT WATER AND LILY PADS

Now start painting the water and lily pads. Use a spray bottle to lightly wet the upper part of the painting, without wetting the flowers. Use the 1-inch (25mm) flat brush to wet the area above the yellowish flower. This way you can wet the area close to the flower without getting the flower itself wet. Pour the three paint colors side by side on the wetted area (the order in which you pour the colors doesn't matter).

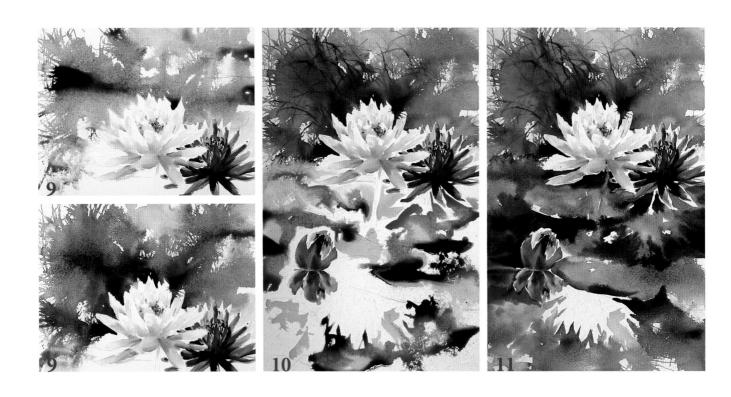

9 BLOW THE PAINT

Blow the paint toward the upper left to create the illusion of grasses. Use a paper towel to remove the excess paint. Use the ¾-inch (19mm) flat brush to mix thick blue and thick red into a dark blue. Paint this color at the top of the yellowish flower to call out the tips of its petals.

10 PAINT GRASSES AND DETAILS

Use the no. 4 round brush to paint more grasses with the thick blue when the colors are about 70 percent dry. Next, wet the rest of the water and lily pad area with the 1-inch (25mm) flat brush and the spray bottle (use the brush for the areas closest to the flowers). Pour the three paint colors, adding more red below the red flower for reflection.

11 BLEND THE COLORS

Use the 1-inch (25mm) flat brush to guide the blending of the thinned paint and to call out the reflection of the yellowish flower and the shapes of the lily pads. While the colors are still wet, mix thick blue with a little thick red into a dark blue to add a darker value to the water.

12 ADD FINISHING DETAILS (NEXT PAGE)

Use the no. 4 round brush to paint the texture of the lily pads with a mixture of blue and a little red. When the colors of the water are almost completely dry, use the ¾-inch (19mm) flat brush to paint the reflection of the yellowish flower. Finally, use the ½-inch (13mm) flat brush with light (diluted) blue to paint the shadows of the yellowish flower's petals.

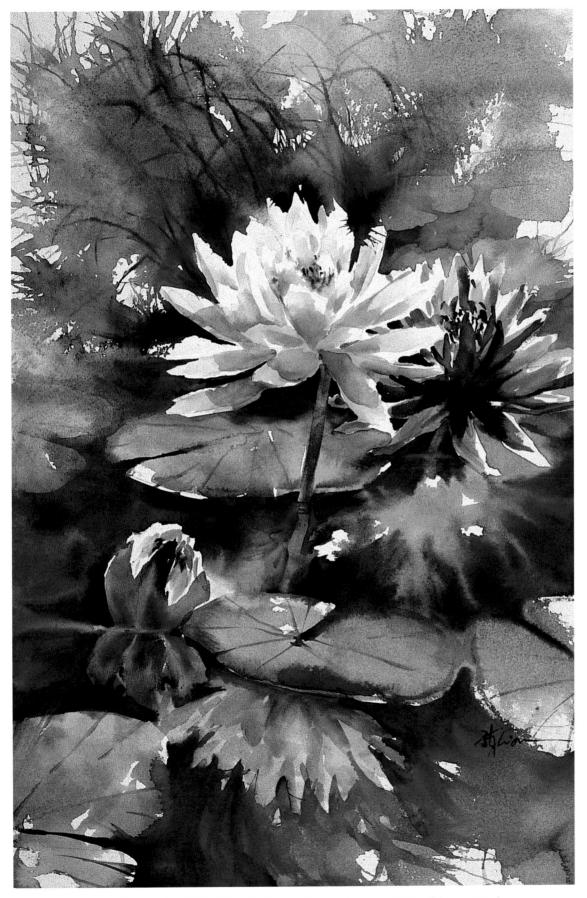

WATER LILY *watercolor on Arches 140-lb. (300gsm) cold-pressed watercolor paper 22" × 15" (56cm × 38cm)*

TOMATO

Tomatoes are rarely featured in Chinese paintings. However, I think their colors are very beautiful, ranging from blue-green to green, yellow, orange, orange-red and red. Also, their long stems and wide leaves are nice features to paint with strokes. I've learned from my painting experience that I can extend the use of a particular method to a variety of subjects. For example, since I don't know of any Chinese paintings of tomatoes, I can use my regular flower-painting techniques to paint this new subject.

�. MATERIALS

PAPER
single-layer raw Shuan paper, 20" × 14" (51cm × 36cm)

BRUSHES
small • medium • large

CHINESE PAINTS
Blue • Carmine • Indigo • Rouge • Vermilion • Yellow

OTHER SUPPLIES
Chinese ink

1 PAINT THE TOMATOES
Load the entire head of a large brush with yellow. Then load the heel with a little blue, the middle with Vermilion and the tip with Rouge. Hold the brush sideways to paint the four tomatoes on the upper right, using two strokes per tomato. Wet another large brush and load it with yellow. Then load the heel with a little Vermilion, the middle to tip with blue and the tip with Indigo. Hold the brush sideways to paint the three tomatoes on the middle left. Use a small brush to outline the reddish tomatoes with a mixture of Rouge and ink, and the greenish ones with a mixture of Indigo and ink.

2 PAINT THE SEPALS AND STEMS
Wet a medium brush and load it with yellow. Then load the middle with blue and the tip with Indigo and Carmine. Hold the brush slightly sideways to paint the sepals. Wet a large brush and load the same colors in the same manner. Hold it straight to paint the stems. Move the brush continuously, but stop for about half a second at each connection and curving point.

3 PAINT THE LEAVES
Load a large brush with yellow, then the middle with Indigo and the tip with ink. Hold the brush sideways to paint the dark leaves. Load the brush with the same colors in the same manner except with less ink at its tip. Paint the light-value leaves.

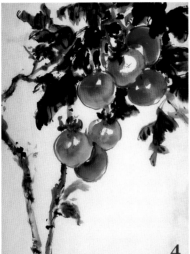

4

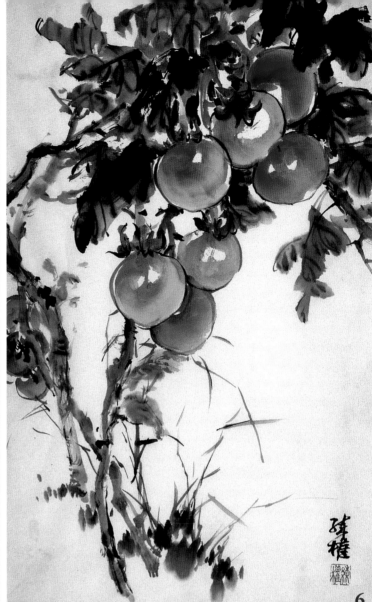

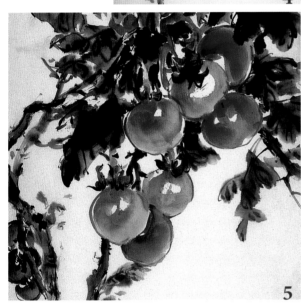

5

6

4 PAINT LEAF, STEM TEXTURE

While the leaves are still wet, load the large brush tip with more ink and paint the veins on the leaves and the texture on the stems.

5 ADD MORE TOMATOES

Use a large brush to add more tomatoes in the background. To paint the three in the lower left and the one on the upper-right edge, load the brush with yellow, the heel with Indigo, the upper middle with blue, and the tip with Carmine. Use a large brush to paint the third stem with yellow, Indigo and ink (mix yellow with a little Indigo and add a little ink to the tip of the brush). This stem should be lighter than the other two in the foreground.

6 ADD FINISHING DETAILS

Finally, use a medium brush to paint the grasses with a little yellow, Indigo and ink (mix yellow with a little Indigo and add a little ink to the tip of the brush). Sign and stamp the lower right to balance the composition.

TOMATO *Chinese ink and color on single-layer raw Shuan paper*
20" × 14" (51cm × 36cm)

TOMATO

You have used masking fluid to block focal-point flowers in previous watercolor demonstrations. Now you will do the opposite: use masking fluid to block the negative spaces between the tomatoes and their foliage. This alternate use of masking fluid works well here. To apply the masking fluid on the negative spaces precisely, you have to make a detailed drawing of the painting to determine where they are.

❈ MATERIALS

PAPER
Arches 140-lb. (300gsm) cold-pressed watercolor paper, 15" × 22" (38cm × 56cm)

BRUSHES
nos. 4 and 10 rounds • ½-inch (13mm), ¾-inch (19mm) and 1-inch (25mm) flats

WATERCOLORS
Antwerp Blue (Winsor & Newton) • Arylide Yellow (Da Vinci) • Naphthol Red Mid-Tone (Da Vinci)

OTHER SUPPLIES
tracing paper • no. 2 pencil • masking fluid • spray bottle

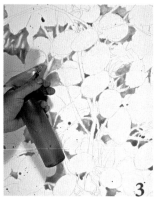
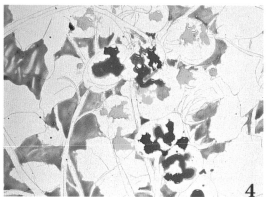

1 *SKETCH THE COMPOSITION ON TRACING PAPER*
Sketch the composition with a no. 2 pencil on tracing paper. Identify the negative spaces (see the hatch patterns) of the painting. You will use masking fluid to block out the negative spaces.

2 *SKETCH THE COMPOSITION ON WATERCOLOR PAPER*
Lightly sketch the composition on watercolor paper with a no. 2 pencil. Apply masking fluid to the negative spaces. Mix the three colors with water in three separate small dishes to create medium-toned mixtures.

3 *SPRAY WATER ON TOMATOES*
Wait for the masking to dry completely. Lightly spray water on the tomatoes.

4 *POUR YELLOW AND RED PAINT*
Pour the yellow paint, then the red paint onto the wet area.

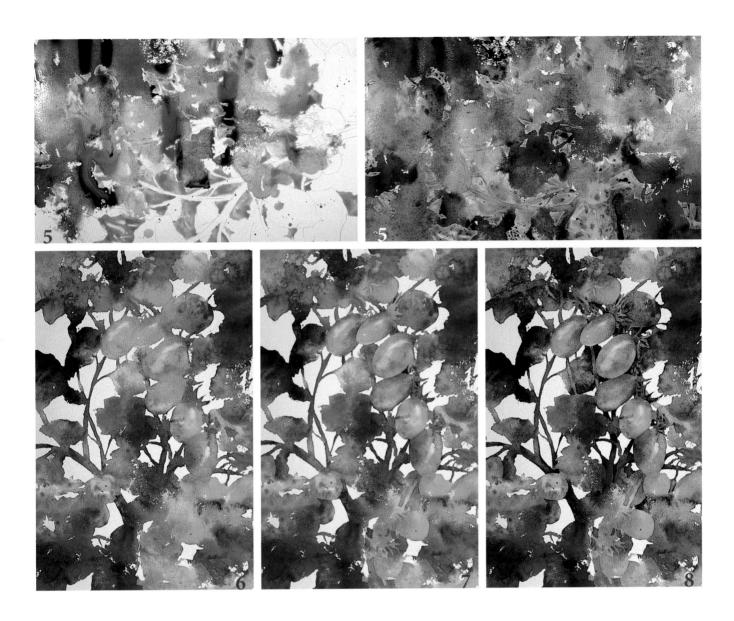

5 SPRAY WITH WATER

Use the spray bottle to lightly wet the rest of the painting. In the leaf area, pour yellow and blue paint. In the tomato area, pour yellow and red. Spray more water on the paint to facilitate blending.

6 ADD HIGHLIGHTS, REMOVE MASKING

When the colors are about 50 percent dry, use the 1-inch (25mm) flat brush to lift colors on the tomatoes, creating highlights. Then wait for the painting to dry completely before removing the masking.

7 USE NEGATIVE PAINTING

Define the tomato shapes with the negative painting technique. Use the no. 4 round brush to paint the outside edges of the tomatoes with blue. Then lightly wet the ½-inch (13mm) flat brush and use it to blend the blue into the base colors next to the tomatoes.

8 CONTINUE NEGATIVE PAINTING

Let the paint to dry. Then further call out the tomato shapes, as well as other objects such as the sepals and stems, using the negative painting technique. Use the no. 4 round brush to mix blue and a little red into a dark blue to paint around the objects. Immediately, use the ½-inch (13mm) flat brush to blend the dark blue away from the tomatoes so the color fades into the base colors around the fruits.

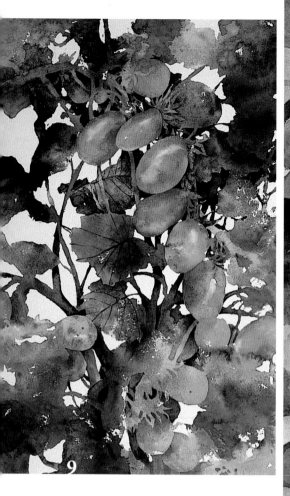

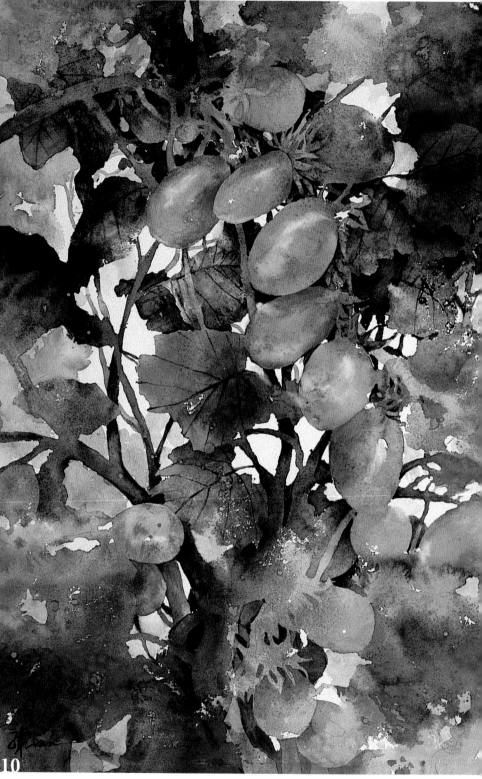

9 DEFINE MORE TOMATOES, STEMS

Define the other tomatoes, stems and leaves in the same manner. The farther away from the focal point the objects are (e.g., the tomatoes on the upper middle right), the less detail they should have.

10 ADD FINISHING DETAILS

Finally, use the ¾-inch (19mm) flat brush to paint the background leaves. Wet the brush and use it to drag the colors of the leaves into the negative spaces. This blurs the edges of the leaves a little, but this is OK. Lightly suggest the shape of the distant leaves.

TOMATO *watercolor on Arches 140-lb. (300gsm) cold-pressed watercolor paper 15" × 22" (38cm × 56cm)*

GRAPES

This demonstration features an interesting combination of elements from northern and southern Chinese painting. Generally, Chinese artists in the north (north of the Yangtze River) use fewer colors and more ink, and emphasize brushstrokes. By contrast, artists from the south (south of the Yangtze River) use more colors, less ink and moderately manipulated brushstrokes. In this painting, you'll observe that the leaves and stems are painted in the northern style and the grapes are depicted in the southern style.

✵ MATERIALS

PAPER
single-layer raw Shuan paper, 14" × 20" (36cm × 51cm)

BRUSHES
small • medium • large

CHINESE PAINTS
Carmine • Indigo • Yellow

OTHER SUPPLIES
Chinese ink

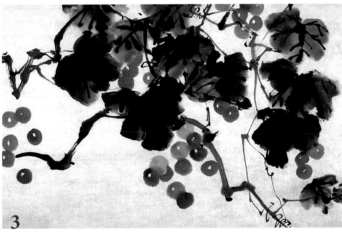
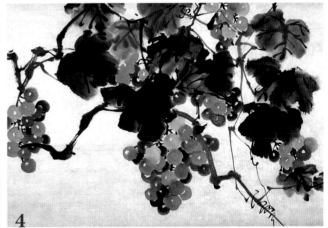

1 PAINT THE VINES
Lightly wet a large brush and load the tip with a little ink. Hold the brush slightly sideways to paint the large vines. Pause for about half a second at the connections and the turns. Use a small brush to paint the small vines in the same manner.

2 PAINT THE LEAVES
Wet a large brush and load the middle and tip with ink. Hold the brush sideways to paint the leaves, using three or four strokes for each leaf. Paint the dark leaves first, then add a little water to the brush to dilute the ink, and paint the light leaves.

3 PAINT LEAF DETAILS, LIGHT GRAPES
While the leaves are still wet, use a medium brush to paint the veins with ink. Next, wet a medium brush lightly and load it with yellow. Then load the lower middle to tip with a little Indigo and Carmine. Hold the brush straight to paint the light-value grapes, using one stroke per grape.

4 PAINT MORE GRAPES
Immediately use the medium brush to paint the dark grapes around and behind the lighter ones. Load the entire brush head with more yellow, and then the middle to tip with more Indigo to paint the medium-value grapes. Add a little ink to the tip to paint the darker ones.

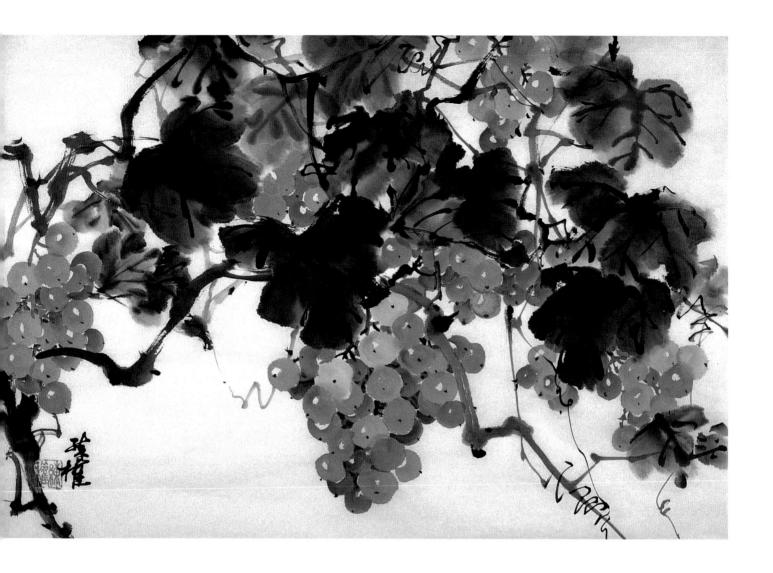

5 ADD FINISHING DETAILS

To paint the grape stems, load a small brush with a mixture of Indigo and ink. Hold the brush straight and paint them quickly. Highlight the grapes in the front with a small dot of ink. Finally, use the large brush to add the vines at the bottom left.

GRAPES *Chinese ink and color on single-layer raw Shuan paper 14" × 20" (36cm × 51cm)*

GRAPES

About two years ago I began developing a new way to paint grapes in watercolor. Without using a detailed sketch or masking fluid, I pour the diluted colors on the paper and use my fingers and brushes to guide the liquids, blending them and forming interesting colors and textures. Then I use the negative painting technique to define the grapes, leaves and stems, following the colors and shapes generated from the color pouring and blending. This method is a lot of fun and allows me the freedom and creativity to find the shapes of the subjects. It's similar to the way children look for images formed by clouds. I'm pleased to share this fun, new method with you.

�֎ MATERIALS

PAPER
Arches 140-lb. (300gsm) cold-pressed watercolor paper, 15" × 22" (38cm × 56cm)

BRUSHES
nos. 4, 8 and 12 rounds • ½-inch (13mm), ¾- inch (19mm) and 1-inch (25mm) flats

WATERCOLORS
Antwerp Blue (Winsor & Newton) • Arylide Yellow (Da Vinci) • Rose Madder (Quinacridone) (Da Vinci)

OTHER SUPPLIES
no. 2 pencil • spray bottle

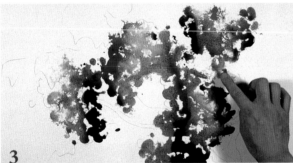
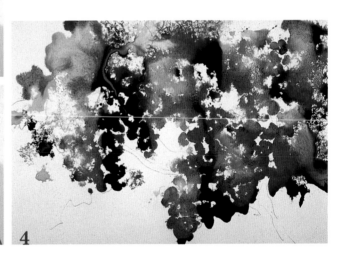

1 SKETCH THE COMPOSITION
Sketch the composition roughly (without details) on the watercolor paper with a no. 2 pencil. Dilute the three colors with water in three separate small dishes, creating medium-toned mixtures. Spray a little water on the grape area.

2 POUR THE RED PAINT
Pour the red paint on the area where the grapes are located.

3 POUR THE BLUE PAINT
Pour the blue paint on the same area. Spray a little more water to facilitate blending. Use your fingers to drag the colors, painting little circles to form grapes.

4 DEVELOP THE LEAVES
Spray water on the leaf areas. Pour the yellow and blue paints. Spray more water for blending. Use your fingers and/or the 1-inch (25mm) flat brush to guide the blending.

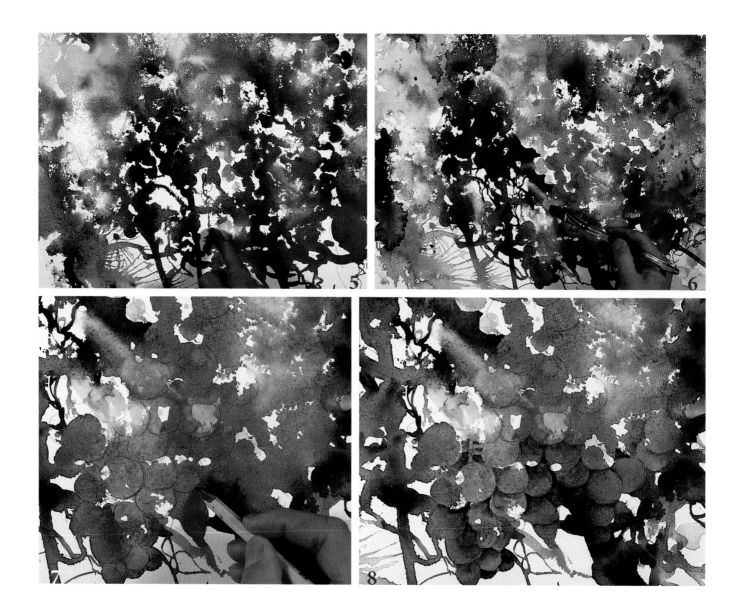

5 TILT THE PAINTING

Tilt the upper left of the painting up about 4 inches (10cm) so the paint flows down toward the lower right. While the paint is flowing down, use your fingers and fingernails to guide it, forming the vines. Use your fingers to paint the large vines, and your fingernails to paint the small vines. Blow the paint on the lower left toward the right to create texture.

6 PAINT CONTRAST

Use the ¾-inch (19mm) flat brush to mix thick blue with a little thick red, making a dark blue. Paint around the grapes randomly to create value contrast. When the colors are about 60 percent dry, lightly wet the ¾-inch (19mm) flat brush and use it to lift the colors, creating the light beams.

7 IDENTIFY THE GRAPES

When the colors are completely dry, use a no. 2 pencil to lightly sketch the grapes. Start from the edge or bottom of the group where the circular edges seem to suggest grapes.

8 USE NEGATIVE PAINTING

Define each grape using the negative painting technique. Starting at the bottom of each group, use the no. 4 round brush to apply blue to the background, blending so that the color becomes lighter as it moves away from the grapes. Also apply blue to the dark places where the grapes overlap. Immediately use the no. 8 round brush to blend the blue into those overlapping grapes. The blue should fade into the grapes, but not mask the original colors.

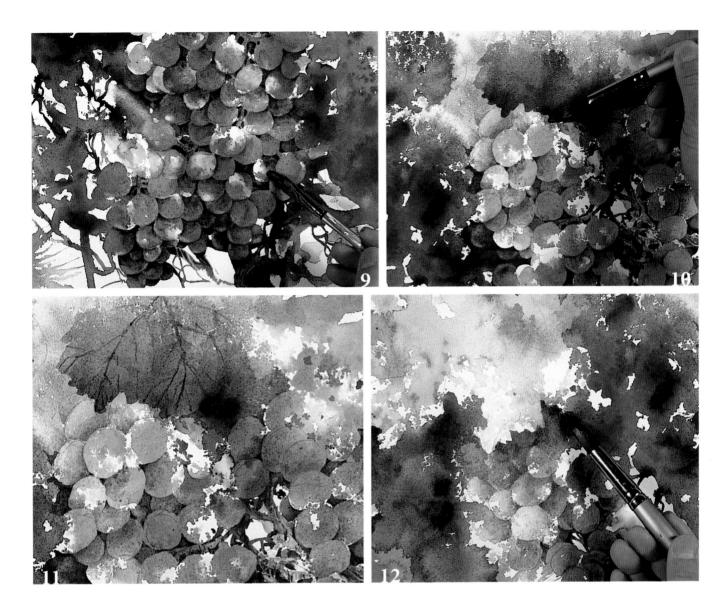

9 HIGHLIGHT STEMS

Use blue and the negative painting technique to define the stems. The base colors created by the pouring technique in the earlier steps will remain as the stem color. The darker the base colors, the darker the blue should be. Lightly wet the ½-inch (13mm) flat brush and use it to lift the colors on the grapes, creating highlights.

10 DEFINE THE LEAVES

After defining the grapes, call out the leaves. One approach is to paint the leaves (positive painting). Wet the no. 12 round brush and load the entire brush head with yellow, then the middle and tip with blue. Hold the brush sideways with the tip aligned with the tip of the leaf. The leaf color should be darker than that of the grapes.

11 PAINT THE LEAF VEINS

When the leaf colors are about 80 percent dry, use the no. 4 round brush to paint the veins with blue and red.

12 USE NEGATIVE PAINTING

Another way to call out the leaves is to use the negative painting technique. Use the no. 12 round brush to define the edges of the leaves by painting the grapes behind the leaves with the dark blue mixture from Step 6. Then use the ½-inch (13mm) flat brush to blend the blue so that it fades into the grapes.

13 CONTINUE PAINTING LEAVES

When the leaves next to the grapes are complete, continue to paint the remaining leaves the same way. The lighter the leaves, the lighter the blue should be. Follow the suggestion of the colors and shapes on the painting to form a variety of leaf shapes.

14 ADD FINISHING DETAILS

The closer they are to the grapes, the more detailed the leaves should be and vice versa. Finally, use the negative painting technique to define more vines. For the vines in the middle right, use the no. 8 round brush to paint the edges with dark blue, then blend the colors onto the leaves with the ½-inch (13mm) flat brush.

GRAPES *watercolor on Arches 140-lb. (300gsm) cold-pressed watercolor paper 15" × 22" (38cm × 56cm)*

HOLLYHOCKS

In my workshops I always mention the importance of value contrast. In this demonstration, you'll learn how to use dark ink and colors to form flower shapes and make the flowers "pop."

✿ MATERIALS

PAPER
single-layer raw Shuan paper, 16" × 20" (41cm × 51cm)

BRUSHES
small • medium • large

CHINESE PAINTS
White • Yellow • Carmine • Rouge • Green Label Three • Blue • Indigo

OTHER SUPPLIES
Chinese ink

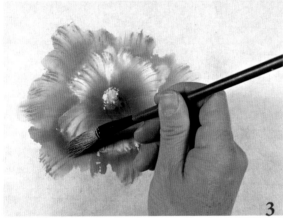

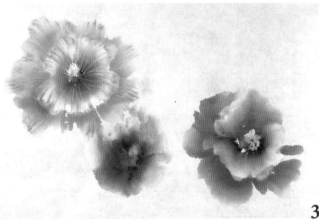

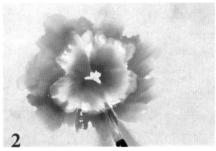

1 START PAINTING THE PETALS
Wet a large brush and load it from the heel to the upper middle with white, the lower middle to tip with Carmine and the tip with Rouge. Hold the brush sideways, pointing the tip to the center of the flower to paint the petals.

2 PAINT THE STAMEN AND ADD TEXTURE TO PETALS
Lightly wet a medium brush and load the heel with Green Label Three, the middle with yellow and the tip with white. Hold the brush sideways with the tip pointing up to paint the stamen. Highlight the tip of the stamen with undiluted white. Lightly wet another large brush and split its hairs with your fingers. Load it with a small amount of Rouge to paint the textures on the petals.

3 FINISH PAINTING THE PETAL TEXTURE AND PAINT THE NEXT TWO FLOWERS
Use a small brush to highlight the textures on the petals with thick white. Then paint the two flowers below the same way, following Steps 1 and 2, but using less white.

DEMONSTRATIONS

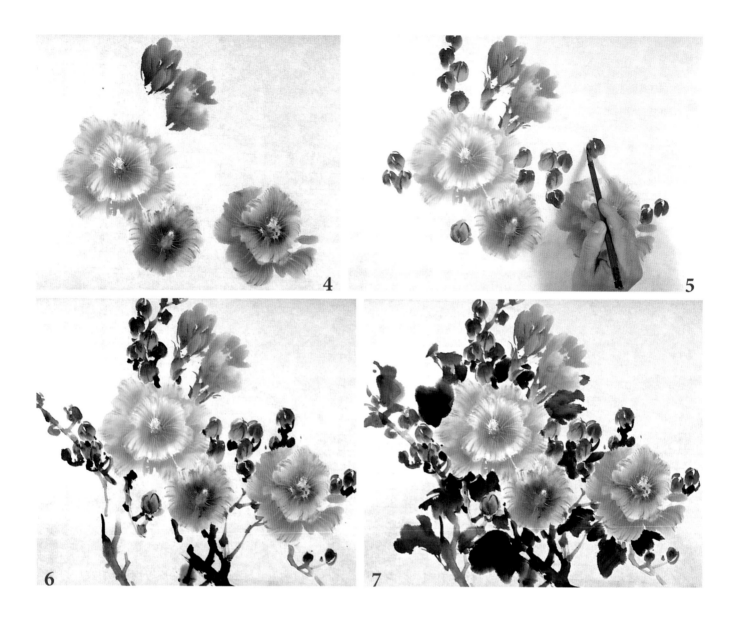

4 PAINT THE HALF-OPEN FLOWERS

To paint the half-open flowers in the upper portion of the composition, wet the large brush and load it with white, Carmine and Rouge (see Step 1). Hold it sideways, pointing the tip toward the bases of the flowers. Use one stroke to form each petal.

5 PAINT THE BUDS AND CALYXES

Wet a medium brush and load the heel with yellow, the middle with Green Label Three, and the tip with blue and Indigo. Hold the brush sideways to paint the buds in two to four strokes. Also, load the colors and paint the calyxes of the two half-open flowers the same way.

6 PAINT THE STEMS

Use a large brush to paint the stems. Load the brush with yellow from the middle to tip, with Indigo from the lower middle to tip and with a little ink at the tip. Hold the brush straight (center brush) to paint the stems. The darker the stems are, the more ink should be used.

7 PAINT THE LEAVES

Wet the large brush and load the entire head with yellow, the middle to tip with Indigo and the tip with ink. Hold the brush sideways to paint the leaves with two to three strokes each. The larger the leaves are, the more pressure you should put on the brush and vice versa. Paint more dark leaves around the light-colored petals.

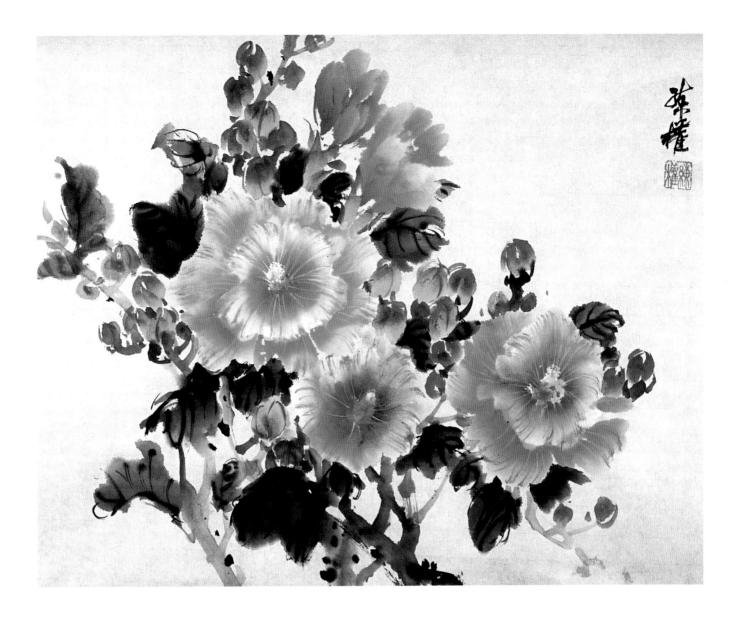

8 ADD VEINS, HIGHLIGHTS AND TEXTURE

Load a small brush with ink to paint the veins. On each leaf, paint the center vein first and then the others. Use dark ink for intensely colored leaves and light ink for light-value leaves. Highlight the dark leaves with a few strokes of blue while their colors are wet. Add ink dots to the stems to suggest texture. Finally, sign and stamp the upper right to balance the composition.

HOLLYHOCKS *Chinese ink and color on single-layer raw Shuan paper* *16" × 20" (41cm × 51cm)*

HOLLYHOCKS

In this demonstration you'll learn how to paint secondary flowers, which are less detailed and defined than focal-point flowers, and sometimes partially blocked by leaves and stems. You'll leave dry areas for the shapes of the flowers, and blow diluted colors to depict the flower textures. Then you'll define the flowers, following the suggestion of the color pouring and blending effects.

✿ MATERIALS

PAPER

Arches 140-lb. (300gsm) cold-pressed watercolor paper, 15" × 22" (38cm × 56cm)

BRUSHES

nos. 4 and 12 rounds • ½-inch (13mm), ¾-inch (19mm) and 1-inch (25mm) flats

WATERCOLORS

Arylide Yellow (Da Vinci) • Rose Madder (Quinacridone) (Da Vinci) • Antwerp Blue (Winsor & Newton)

OTHER SUPPLIES

no. 2 pencil • masking fluid • spray bottle

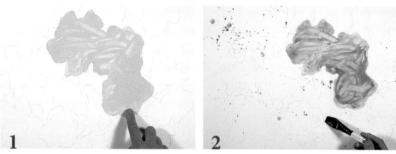

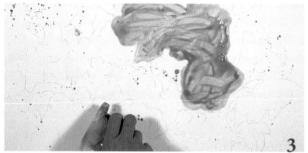

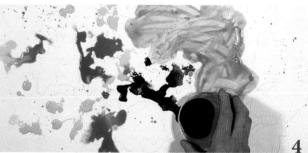

1 SKETCH THE COMPOSITION AND MASK THE FLOWERS

Lightly sketch the composition on the watercolor paper with a no. 2 pencil. Cover the focal-point flowers by pouring masking fluid on them and using your finger to spread it around.

2 DILUTE PAINT AND WET AROUND FOCAL-POINT FLOWERS

Dilute the three colors with water in three separate small dishes, creating medium-toned mixtures. When the masking is dry, use the ¾-inch (19mm) flat brush to wet around the flowers next to the focal point.

3 SPRAY ON MORE WATER

Spray water lightly to wet more areas around the flowers. Use one hand to shield the flowers so they don't get wet.

4 POUR THE PAINT

Pour the diluted paints on the damp area: yellow first, red around the flowers and blue on the leaves.

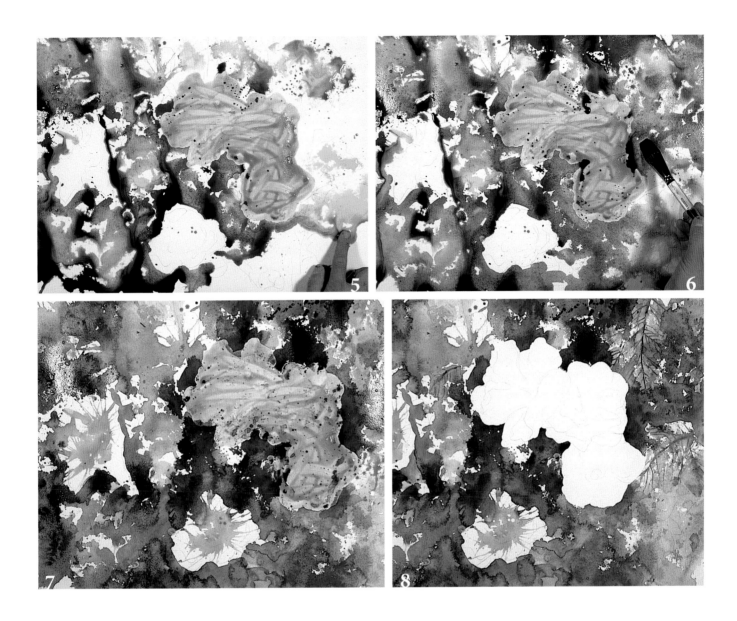

5 SPRAY MORE WATER AND BLEND

Spray a little more water on the paint. Use your fingers and brush to guide their blending. Here you can see the areas that should be left dry for the flowers.

6 PAINT DARK BLUE AROUND THE FLOWERS

Use the ¾-inch (19mm) flat brush to mix thick blue and a little thick red into a dark blue. Paint it randomly around the focal-point flowers. This dark color will contrast with the light value of the flowers.

7 PAINT FLOWER CENTERS AND CREATE PETAL TEXTURE

Use the 1-inch (25mm) flat brush to apply the diluted red and yellow paint to the centers of the three flowers that have, until now, remained white. Blow the color liquids out to the edges of the flowers to create the petal texture.

8 PAINT BACKGROUND, ADD DETAIL TO LEAVES AND REMOVE MASKING

While the background colors are still wet, use the ½-inch (13mm) flat brush to splash the diluted yellow. This will create a yellowish green suggesting the shapes of leaves and stems. To call out the leaves on the right, use the no. 4 round brush to paint the veins with blue and red. Let the painting dry completely before removing the masking.

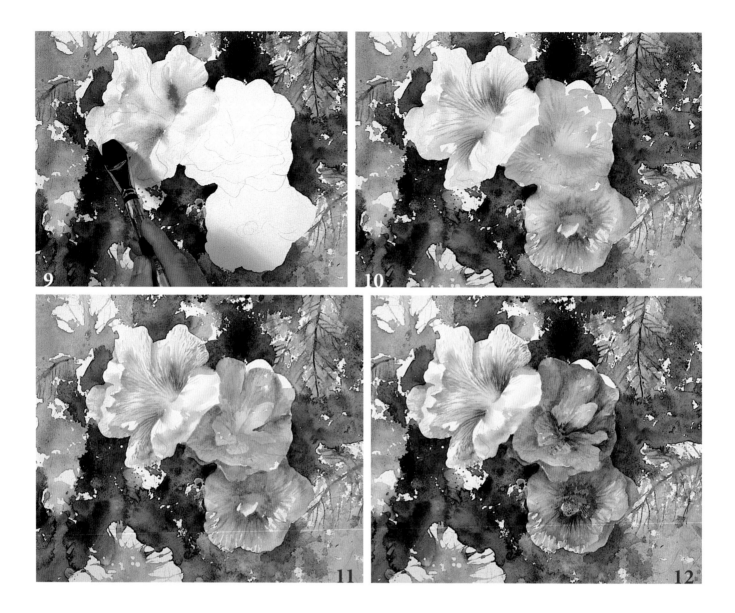

9 SKETCH FLOWER DETAILS AND PAINT TOP FLOWER

Use a no. 2 pencil to lightly sketch the details of the focal-point flowers. Wet the center of the top flower with the 1-inch (25mm) flat brush and paint it with medium-toned (diluted) yellow. Immediately paint red around the yellow so they blend into each other a little. While the red is still wet, use the ¾-inch (19mm) flat brush to gradually blend it toward the petals' tips. Leave the tips white.

10 PAINT THE OTHER TWO FLOWERS

Paint the other two flowers in the same manner. For the one on the lower right, use the ¾-inch (19mm) flat brush to drag the surrounding colors into the petals with a little water. When the colors are about 60 percent dry, use the no. 4 round brush with red to call out the textures.

11 DEFINE THE INDIVIDUAL PETALS

When the flowers are completely dry, define the individual petals. Use the no. 4 round brush to paint red on the edges of the petals. Immediately use the no. 12 round brush to blend the colors with a little water so that the red fades into the petals layered underneath.

12 FURTHER DEFINE THE STAMENS AND PETALS

Let this color layer dry. Use the no. 4 round brush to mix a darker red from thick red with a little blue. Add this color to the center and edges of the petals to further define the stamens and petals. Gradually blend the dark red so it fades into the base colors of the petals layered underneath.

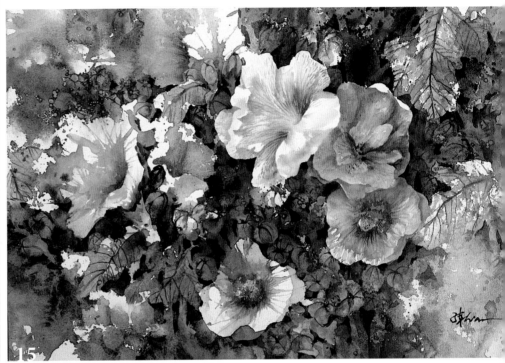

13 PAINT THE OTHER FLOWERS

Using the same technique, paint the stamens in the centers of the secondary flowers and define the petals. However, these flowers should have less detail and definition than the focal-point flowers.

14 DEFINE THE BUDS, LEAVES AND STEMS

When you've completed all the flowers, use the negative painting technique to define the buds, leaves and stems. The light-colored spots (yellowish green) will become the buds. Use the no. 4 round brush to paint around them with diluted blue, then use the ½-inch (13mm) flat brush to blend the blue so that it gradually fades into the background. Define the leaves and stems the same way.

15 PAINT THE DETAILS ON THE BUDS AND LEAVES

Finally, use the no. 4 round brush to paint the details on the buds and veins on the leaves with blue. The closer to the focal point these objects are, the more detail they should have, and vice versa. Sign your name on the lower right to balance the composition.

HOLLYHOCKS *watercolor on Arches 140-lb. (300gsm) cold-pressed watercolor paper 15" × 22" (38cm × 56cm)*

CHRYSANTHEMUM

This painting is a typical example of my floral watercolor style. There's an emphasis on detail in the focal-point flowers and a gradual reduction of detail and definition in the others. I used masking fluid to carefully block the three focal-point flowers so I could paint details after the color pouring and blending. I didn't use making fluid to cover the other flowers because they're in the background and don't require details or defined shapes. This concept relates to photography: When a camera lens is focused to take a close shot of a grouping of flowers, the flowers in the foreground will be clear, but those in the background will be blurred.

✿ MATERIALS

PAPER

Arches 140-lb. (300gsm) cold-pressed watercolor paper, 15" × 22" (38cm × 56cm)

BRUSHES

nos. 4 and 8 rounds • ½-inch (13mm), ¾-inch (19mm) and 1-inch (25mm) flats

WATERCOLORS

Arylide Yellow (Da Vinci) • Rose Madder (Quinacridone) (Da Vinci) • Antwerp Blue (Winsor & Newton)

OTHER SUPPLIES

no. 2 pencil • masking fluid • spray bottle

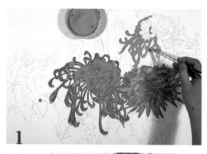
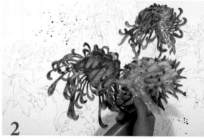

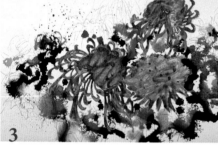
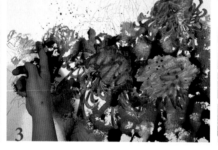

1 Sketch the Composition and Apply Masking Fluid

Lightly sketch the composition on the watercolor paper with a no. 2 pencil. Use the wedge-shaped end of a ½-inch (13mm) flat brush to apply the masking fluid to the focal-point flowers.

2 Dilute the Paint and Spray Water Around the Flowers

Dilute the three colors with water in three separate small dishes, creating medium-toned mixtures. When the masking is dry, lightly spray water on the area around the masked flowers.

3 Pour the Diluted Paint

Pour the diluted paint on the wet area: red and yellow on the background flowers and buds, blue and yellow on the leaves. Guide the colors with your fingers to paint the flowers on the left.

4 Pour and Blow Paint to Create Flowers

Pour diluted red and a little blue on the upper-middle area. Blow the paint downward to create the shapes of the reddish flowers. Likewise, pour yellow and a small amount of red on the upper left and blow it toward the middle right to create the shape of a yellowish mum.

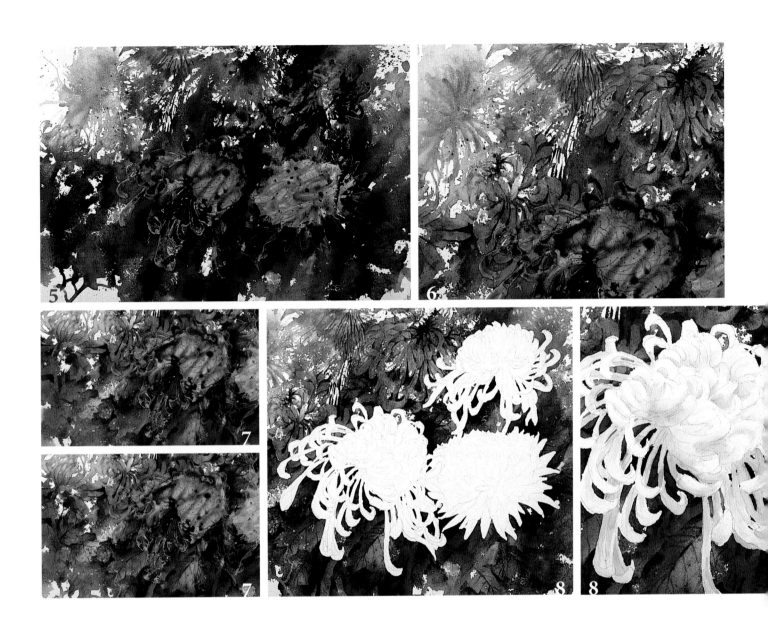

5 TILT THE PAINTING, PAINT AROUND THE FOCAL-POINT FLOWERS

Tilt the upper right corner of the board up about 6 inches (15cm) for about a minute so the paint flows down toward the lower left. Use the ¾-inch (19mm) flat brush to mix thick blue with a little thick red to create a dark blue. Paint this color randomly around the focal-point flowers, which will be lighter in color.

6 DEFINE THE FLOWER SHAPES

When the background flowers are about 80 percent dry, define the flower shapes. For the yellowish one in the upper left, use the no. 8 round brush to paint the petals with an orange mixture created from yellow and a little red. For the other flowers, paint around the petals using a mixture of blue and red that is darker than the local colors. Then gradually blend the color into the local colors.

7 DEFINE THE LEAVES AND PAINT THE VEINS AND STEMS

Use the no. 8 round brush to paint around the edges of the leaves with a color (blue or a mixture of blue and red) that is darker than the local colors. Use the ½-inch (13mm) flat brush to blend it into the local colors. Use the no. 4 round brush to paint the veins with a mixture of blue and red. The darker the leaves are, the darker the mixture of blue and red should be. Paint the stems in the same manner.

8 REMOVE THE MASKING AND PAINT THE FOCAL-POINT FLOWERS

Remove the masking when the painting is completely dry. Use the pencil to lightly sketch details on the focal-point flowers. To paint the yellowish mum, use the no. 4 round brush to apply a small amount of yellow to the bases of the petals. Then lightly wet the ½-inch (13mm) flat brush and use it to gradually blend the color into the middle of the petals. Leave the tips white.

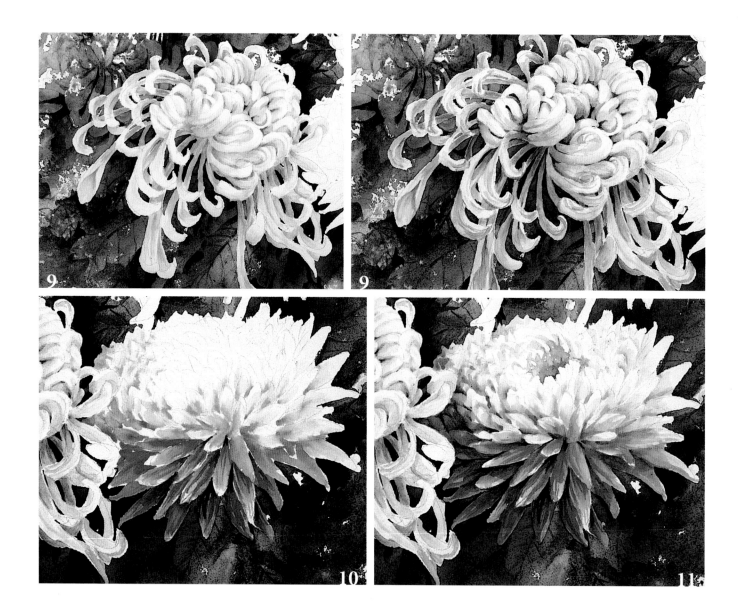

9 ADD RED AND BLUE TO THE FLOWER

Let the yellow dry, then use the no. 4 round brush to apply a small amount of red to the bases of the petals. Then use the ½-inch (13mm) flat brush to blend the paint toward the middle of the petals. When the red is dry, add blue in the same manner.

10 PAINT THE RED FLOWER

Next, define the petals of the reddish flower using the same technique. Use the no. 4 round brush to paint the bases of each petal on the lower part of the flower with red. Then use the ½-inch (13mm) flat brush to blend the paint to the tips. Leave white at the center of the flower.

11 APPLY DARK RED TO THE RED FLOWER

Let the red dry. Add a dark red made from thick red and thick blue to the bases of the petals. Blend the dark red into the middle of the petals and leave white on the tips. At the center of the flower, use the same brush to define the smaller petals with yellow and blue.

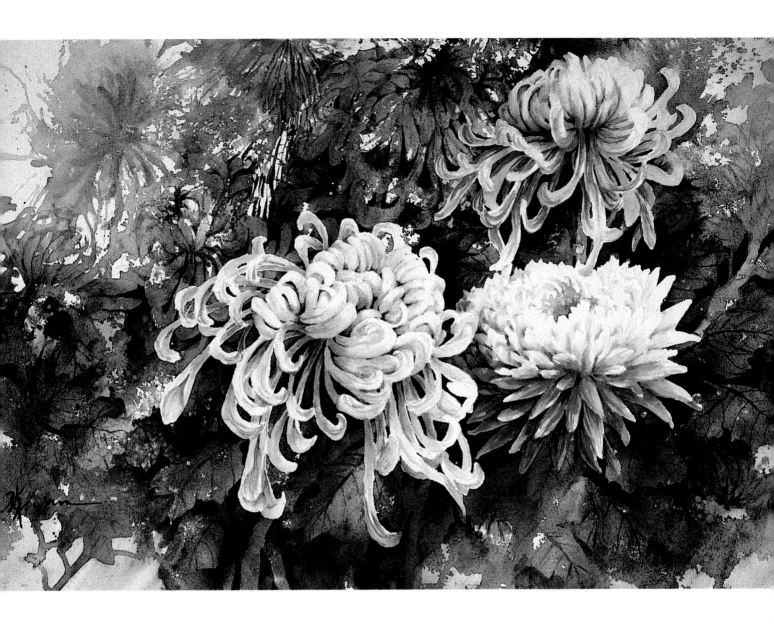

12 *Paint the Red Mum in the Upper Right*

Paint the reddish mum at the upper right using the same method, but this time use only red and blue. Finally, lightly wet the 1-inch (25mm) flat brush and use it to pull the colors from the leaves into the background.

CHRYSANTHEMUM *watercolor on Arches 140-lb. (300gsm) cold-pressed watercolor paper*
15" × 22" (38cm × 56cm)

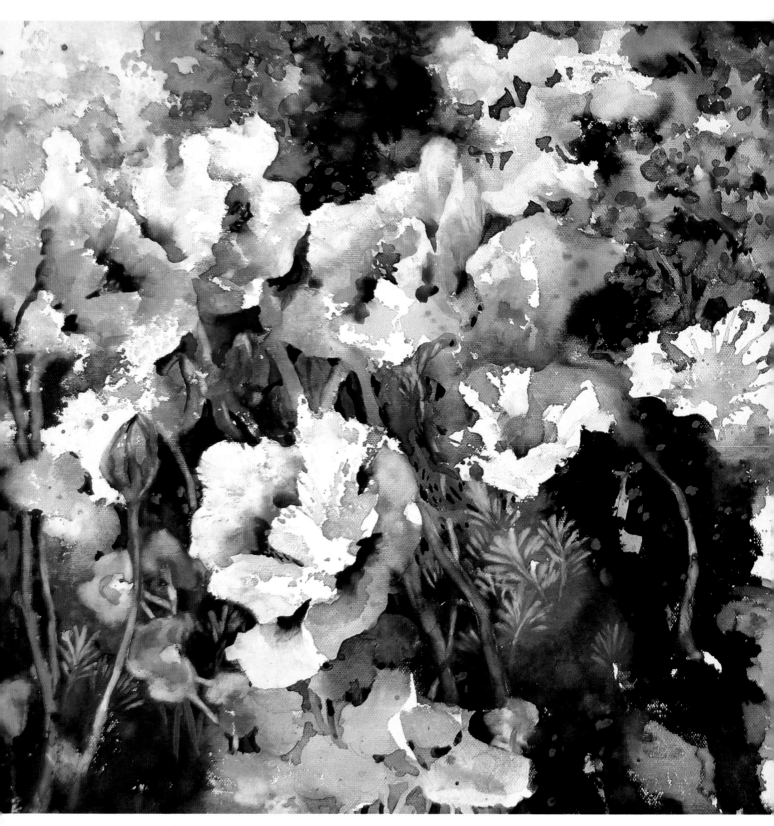

POPPIES *Chinese ink and color on primed canvas 16" × 20" (41cm × 51cm)*

4 EXPERIMENTAL
CHINESE PAINTING TECHNIQUES

Starting in the late seventeenth century, Western painting techniques were introduced concurrently with Christianity in China. The Western painting techniques were appreciated by the emperors who had their portraits painted by the foreigners. Consequently, the court painters were exposed to Western art. A handful of them learned the foreign techniques and integrated them into Chinese painting.

In the early twentieth century, Chinese artists studied abroad in Europe and Japan. Those who went to Europe brought back Western painting media, methods and styles. Those who studied in Japan were influenced by modern Japanese painting techniques, which combined Japanese and Western painting. Thus, oil, watercolor and sculpture gained popularity in China.

Since the early 1950s, college-level art students in mainland China are required to study Western sketching, painting theory and technique, regardless of whether they major in Chinese or Western art. Now many Chinese artists are moving beyond traditional Chinese painting methods. In addition to adopting Western painting techniques, these artists are experimenting with Western materials. The following demonstrations exemplify these experiments.

PRINTING WITH GLASS—WISTERIA

In this demonstration you'll learn how to make a print from painted glass on raw Shuan paper, and then adjust the image into recognizable objects. This technique produces unexpected and magical effects.

�֎ MATERIALS

PAPER
raw Shuan paper, 20" × 14" (51cm × 36cm)

BRUSHES
small • medium • large

CHINESE PAINTS
White • Yellow • Vermilion • Carmine • Indigo

OTHER SUPPLIES
Chinese ink • piece of glass approximately 3 inches (8cm) larger than the raw Shuan paper • spray bottle • felt mat

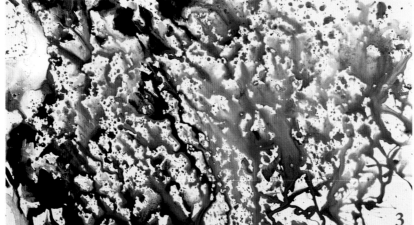

1 *Spray Water and Splash Paint on the Glass*
Lightly spray water on the glass. Use the medium and large brushes to splash and paint yellow, white, Carmine, Indigo and ink on the glass. At this stage I decided to use a horizontal composition.

2 *Add More Paint and Tilt Glass*
Add more Carmine and white to the glass. Tilt the upper-left corner of the glass up 2 inches (5cm) for about one minute so the colors flow down to the lower right slightly.

3 *Press the Paper on the Glass*
Lay the glass flat again. Place the raw Shuan paper on the glass (either side is OK). Use your hands to lightly press the paper down onto the glass. Let the paper absorb and blend the colors.

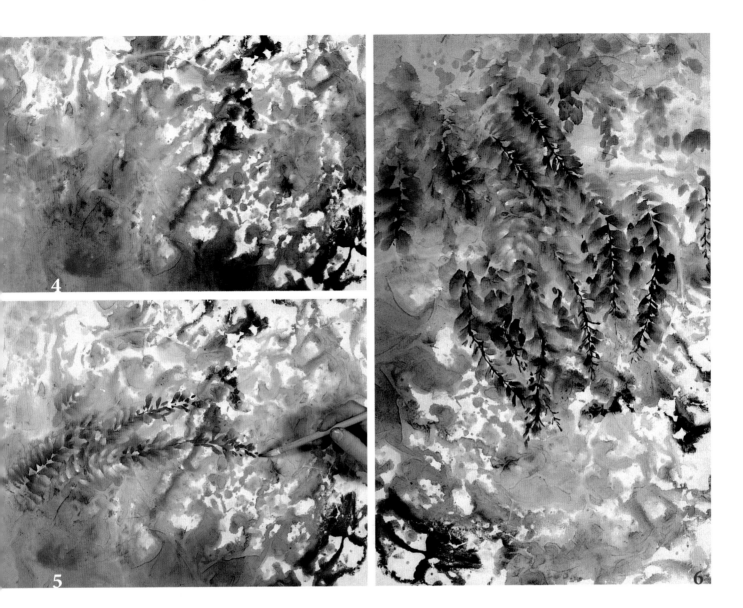

4 LIFT THE PAPER

Wait a couple of minutes before lifting the paper. Place it on a felt mat with the printed side up. At this point I decided to change the orientation of the painting because the vertical composition looked better.

5 BEGIN TO PAINT THE FLOWERS

Lightly wet a medium brush and load it from the heel to middle with white, the middle to tip with Carmine, and the tip with a mixture of Carmine and Indigo. Hold the brush sideways to paint the flowers, a single stroke per petal.

6 PAINT MORE FLOWERS

Continue to paint more flowers the same way. Use the small brush to connect the petals with Carmine and ink.

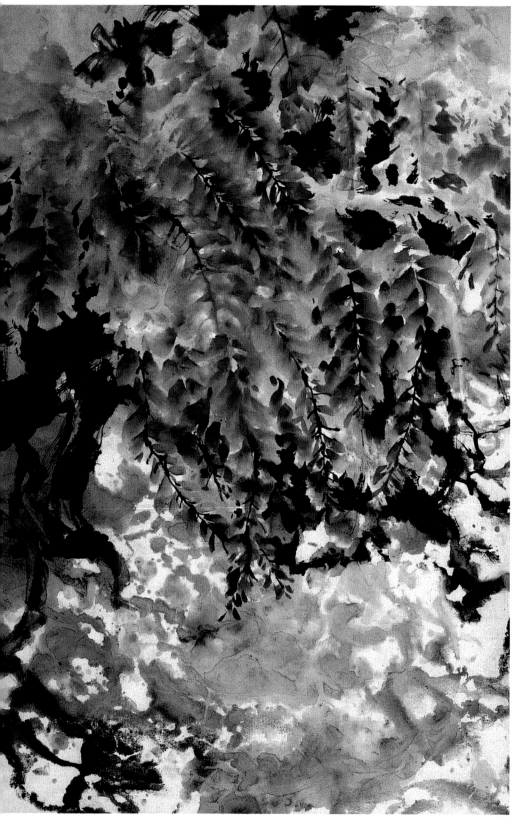

7 PAINT THE VINES

When the painting is about 90 percent dry, use a large brush to paint the vines. Load the tip and middle with ink and hold it sideways to paint the vines with minimal strokes (one or two strokes per vine). Finally, use a medium brush to paint the small, dark vines behind the flowers to call out the shapes of the flowers and the lighter vines.

WISTERIA *Chinese ink and color on raw Shuan paper 20" × 14" (51cm × 36cm)*

USING GLUE AS A RESIST—CACTUS

This demonstration illustrates another nontraditional use of materials: applying glue and water before painting on mature Shuan paper. The glue provides resistance to the flowing and mixing of the paint. The colors blend slowly, creating soft and waxy effects.

�MATERIALS LIST

PAPER
mature Shuan paper, 14" × 18" (36cm × 46cm)

BRUSHES
small • medium • large

CHINESE PAINTS
White • Yellow • Vermilion • Scarlet • Blue • Indigo

OTHER SUPPLIES
Chinese ink • white craft glue

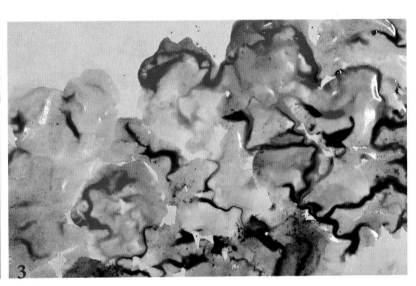

1 CREATE GLUE MIXTURE AND APPLY TO PAPER
Mix the white glue with clear, cold water. The ratio of glue to water should be approximately 1:5 (if you want more color blending, use less glue and vice versa). Use a large brush to apply a thin, even layer of the glue mixture to the mature Shuan paper.

2 PAINT THE CACTUS FLOWERS
While the paper is still wet, use a large brush to paint the cactus flowers with Scarlet.

3 ADD YELLOW TO THE FLOWERS AND PAINT THE STEMS AND BACKGROUND
Immediately use a large brush to paint yellow on the lower portion of the flowers and paint Indigo on the stems and the background. Allow the colors to blend slightly.

EXPERIMENTAL CHINESE PAINTING TECHNIQUES

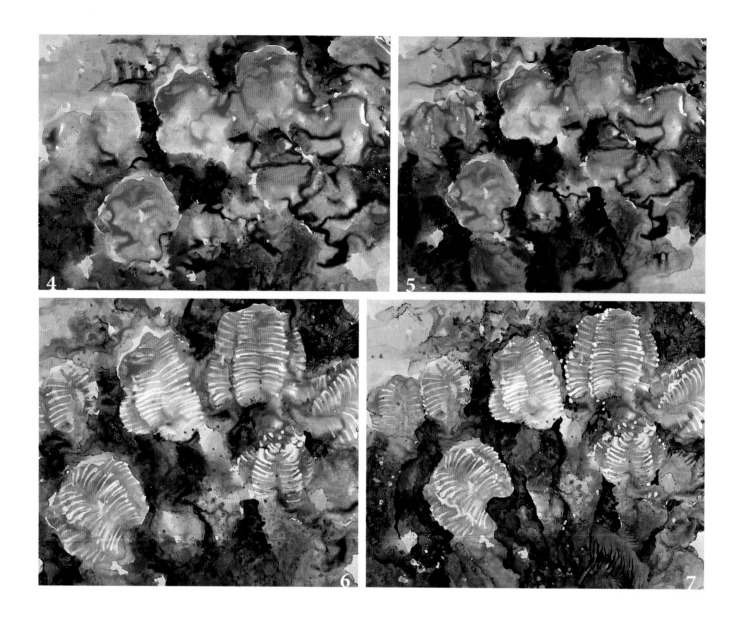

4 PAINT THE UPPER LEFT AND AROUND THE FLOWERS
Continue using a large brush to apply yellow at the upper left of the painting and ink and Indigo around the flowers.

5 DEFINE THE FLOWERS AND STEMS
The colors will flow slowly and blend on the paper, creating interesting shapes and textures. It isn't necessary to tilt the painting; the colors will flow and blend on their own. When the paint is about 60 percent dry, use a medium brush to mix ink and Indigo, then paint around the flowers and stems, defining their shapes.

6 PAINT THE FLOWER DETAILS
While the flowers are slightly damp, use a medium brush to paint the details of the flower with thick white.

7 DEFINE THE STEMS WITH NEGATIVE PAINTING
When the painting is dry, use the negative painting technique to call out the stems with ink and Indigo. Paint around the stems, then blend the ink and Indigo away from the stems so the color fades into the background.

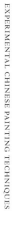

8 *PAINT THE THORNS AND SIGN THE PAINTING*

Finally, use the small brush to paint the thorns with thick white and a little Scarlet.

Sign and place your chop on the lower right to balance the composition.

CACTUS *Chinese ink and color on mature Shuan paper 14″ × 18″ (36cm × 46cm)*

CRINKLING RICE PAPER—ORCHIDS

Crinkling Shuan paper to depict the texture of snow, trees and rocks is a common practice in Chinese art. This demonstration shows you how to use this method to create the texture of orchid leaves, stems, grasses and dirt.

✿ MATERIALS

PAPER

mature Shuan paper, 22" × 16" (56cm × 41cm)

BRUSHES

small • medium • large

CHINESE PAINTS

White • Yellow • Vermilion • Carmine • Rouge • Burnt Sienna • Blue

OTHER SUPPLIES

Chinese ink

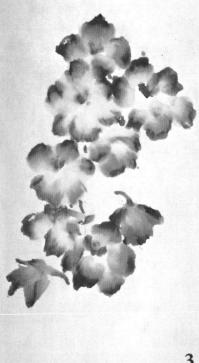
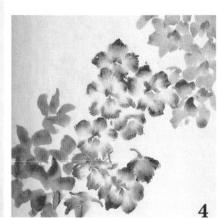

1 PAINT THE PETALS

Wet a large brush and load the middle and heel with white and the middle and tip with Carmine. Hold the brush sideways to paint the petals, pointing the tip away from the center of the flowers. Use one stroke per petal.

2 PAINT THE FLOWER CENTERS AND SMALL STEMS

Use a medium brush to paint the centers of the flowers with blue. Then mix yellow and blue to paint the small stems.

3 PAINT THE LABELLUM AND THE VEINS OF THE PETALS

Load yellow on the entire head of a medium brush, then load Carmine at the tip. Paint the center of the labellum. Lightly wet a small brush and split the tip with your fingers. Load the tip with a little Rouge to paint the veins of the petals.

4 PAINT THE YELLOW-ORANGE FLOWERS

Paint the yellow-orange flowers the same way but using yellow and Vermilion. Load the heel to middle of a large brush with yellow, then load the tip with Vermilion to paint the petals.

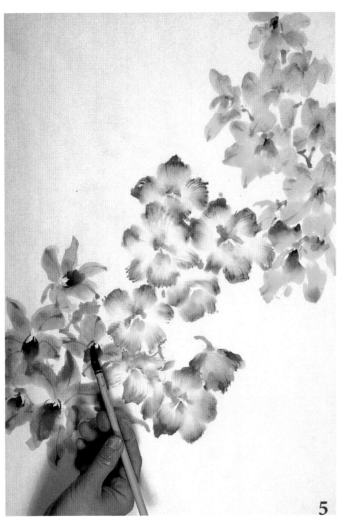

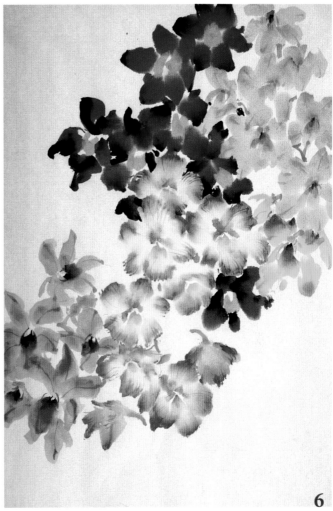

5 *PAINT THE CENTER OF THE LABELLUM AND THE PETALS*

While the colors are still wet, paint the center of the labellum. Load the entire head of a medium brush with Carmine, then load the middle and tip with Rouge. Dip the tip in a little ink. Hold the brush sideways to paint. Next, use a small brush to paint one stroke at the center of each petal with Carmine.

6 *PAINT THE DARK-RED FLOWERS*

Now paint the dark red flowers with a large brush. Load the entire brush head with Carmine, then load the middle to tip with Rouge and dip the tip in a little ink. Hold the brush sideways, pointing the tip away from the center of the flowers to paint the petals. Leave white at the center of the flowers. While the petals are still wet, use a medium brush to paint the centers with a mixture of yellow and Vermilion.

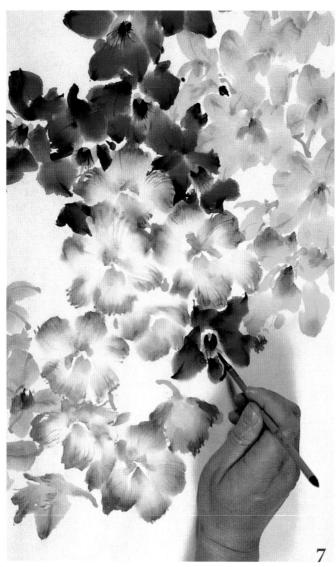

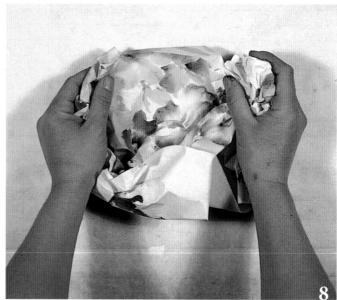

7 ***PAINT THE CENTER OF THE LABELLUM***

Load the entire head of a small brush with Carmine, then load the tip to middle with Rouge and place a little ink on the tip. Hold the brush sideways to paint the center of the labellum, leaving orange in the middle as the stamen.

8 ***CRINKLE THE PAPER***

Let the painting dry completely, then use both hands to crinkle the painting.

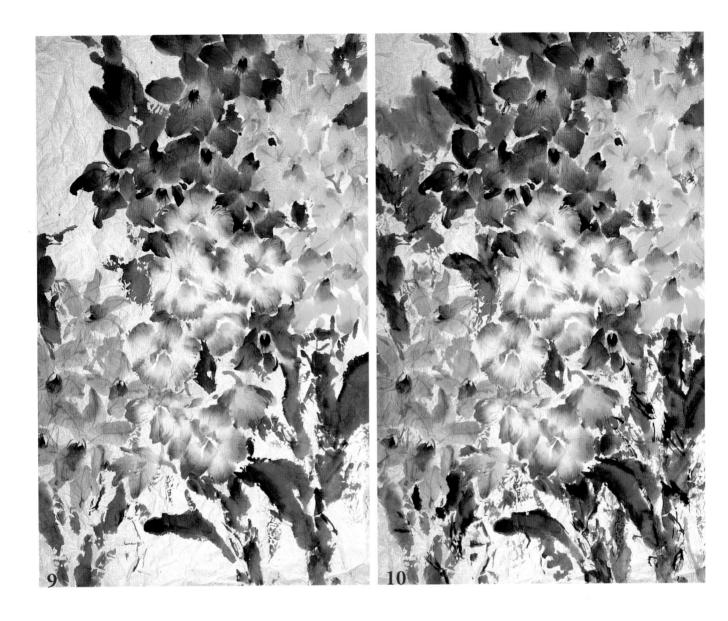

9 SPREAD THE PAINTING AND PAINT THE STEMS AND LEAVES

Use both hands to carefully spread the painting as flat as possible. Lay it on the felt mat on your painting table. Wet a large brush and load it with yellow, then a little Vermilion, from the upper middle to tip, and blue from the middle to tip. Place a little ink on the tip. Hold the brush sideways to paint the stems and leaves with one stroke for each.

10 PAINT MORE LEAVES AND CREATE TEXTURE ON THE LEAVES AND STEMS

Continue to use the large brush to paint light-colored leaves with yellow, Vermilion and a little blue. Use a medium brush with ink to call out the veins of the leaves and the texture of the stems.

EXPERIMENTAL CHINESE PAINTING TECHNIQUES

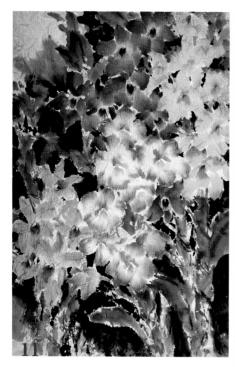

11 PAINT THE BACKGROUND DIRT

Lightly wet a medium brush and load the entire brush head with Burnt Sienna, then load the middle to tip with ink. Paint around the flowers, leaves and stems to create the appearance of dirt in the background.

12 PAINT THE GRASSES

Finally, use a small brush to paint the grasses in the lower left with ink.

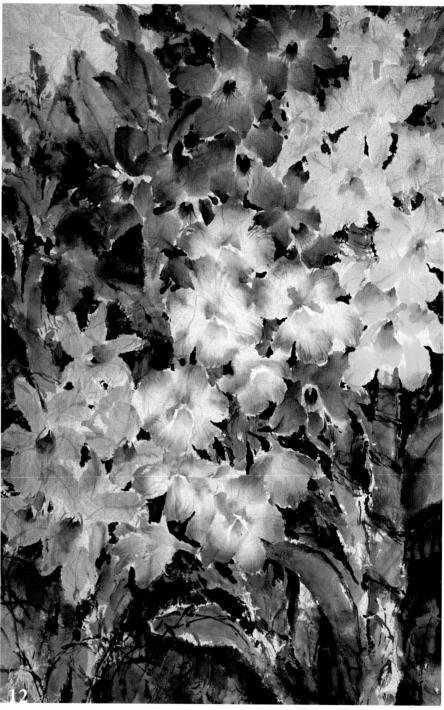

ORCHIDS *Chinese ink and color on mature Shuan paper 22" × 16" (56cm × 41cm)*

PAINTING ON PRIMED CANVAS—POPPIES

My wife paints with oils, and we share the same studio at home. One day, I accidentally dripped some Chinese paint on one of her canvases, and I could not remove the paint completely. Rather than discarding the canvas, I tried to paint on it with Chinese pigments and ink. I was surprised by the outcome: The colors appeared more vivid than they do on Shuan paper. Also, the colors can be partially lifted to create beautiful effects.

❈ MATERIALS

SURFACE
oil canvas, 16" × 20" (41cm × 51cm)

BRUSHES
Chinese brushes: small • medium • large • watercolor brushes: nos. 4, 8 rounds • ¼-inch (6mm) flat

CHINESE PAINTS
White • Yellow • Vermilion • Carmine • Rouge • Blue • Indigo

OTHER SUPPLIES
Chinese ink • spray bottle

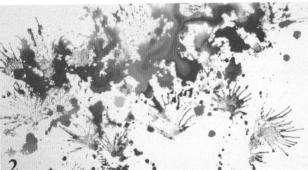

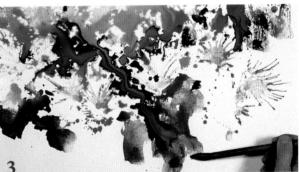

1 *ORGANIZE THE COMPOSITION MENTALLY AND SPRAY WATER IN THE UPPER AREA OF THE CANVAS*
I first organize the composition mentally. Poppy flowers will be the focal point in the upper-left portion of the canvas. Other flowers and plants will be scattered randomly in the background. To start painting, lightly spray water on the upper area of the canvas.

2 *SPLASH PAINT AND CREATE TEXTURE*
Use the watercolor brushes to splash yellow, Vermilion and Carmine on the wet area. Blow the colors to suggest the texture of the petals. (Blow straight down so the color disperses in all directions.)

3 *PAINT INDIGO AROUND THE FLOWERS*
Use a medium Chinese brush to paint Indigo around the flowers. Allow the Indigo to blend into the other colors a little.

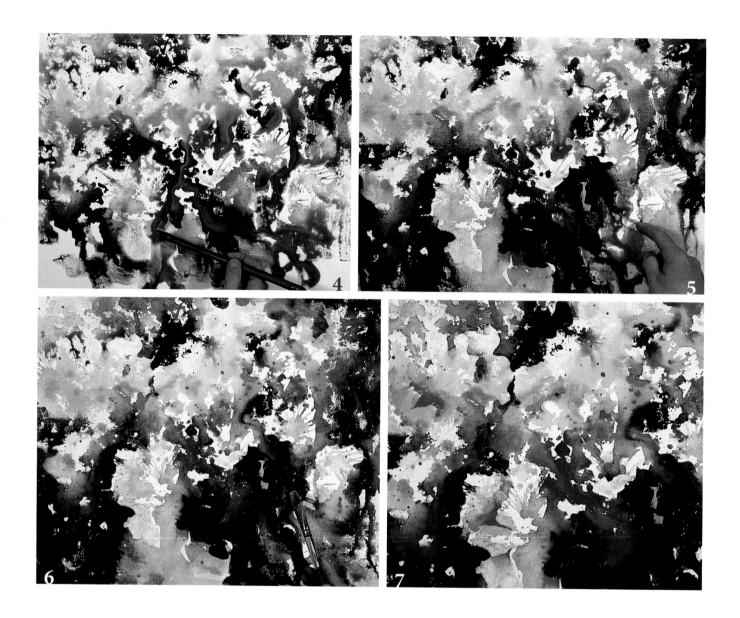

4 SPRAY MORE WATER AND TILT THE CANVAS

Spray water on the upper left and the lower part of the canvas. Tilt the upper edge of the canvas up 2 inches (5cm) to allow the colors to flow down and blend. Use a medium Chinese brush to guide the flow.

5 ADD INK AROUND THE FLOWERS AND MIX THE COLORS

With the same Chinese brush, add ink around the flowers. Use your fingers to guide the flowing and mixing of the colors.

6 SPLASH PAINT AROUND THE BACKGROUND FLOWERS

Use a ¼-inch (6mm) flat brush to splash yellow, then blue around the flowers in the background. It's OK to leave the splashed colors on the flowers.

7 DEFINE THE CENTER OF THE FLOWERS

Next, use the no. 4 round brush to define the centers of the flowers with Carmine. Then blend the color toward the tips of the petals with a slightly wet no. 8 round brush.

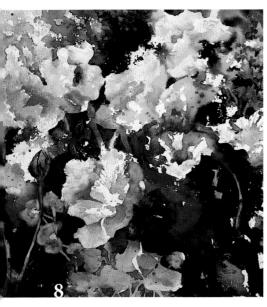

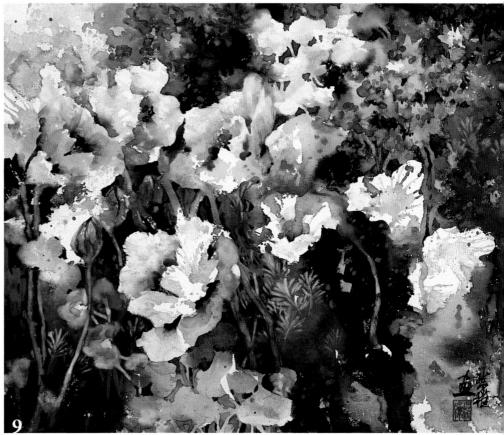

8 DEFINE THE SHAPES WITH NEGATIVE PAINTING

Use the watercolor brushes to define the shapes and stems of the flowers and the plants. Use the no. 4 round brush to paint around those objects with Indigo and ink, then blend the Indigo and ink away from the objects, fading into the background colors. The darker the base colors are, the more ink should be used.

9 CREATE STEMS AND PLANTS THROUGH LIFTING

Finally, use the no. 4 round brush to lift colors to create the stems and plants. (Lightly wet the brush and use it to remove color.)

POPPIES *Chinese ink and color on oil canvas 16" × 20" (41cm × 51cm)*

INDEX

Background, 55
 abstract, 69
 flowers, 62
 leaves, 92
 spontaneous, 48
Balance, 18, 33, 51, 53, 61, 83, 89, 101, 105, 117
Bamboo, 33
Banana tree, spontaneous-style, 74–75
Bird, 35
Bird of paradise, 32
Blending, 22, 25
 Chinese paint, 20
 watercolor, 22–23, 25, 55–56, 63
Brush tip, splitting a, 72
Brushes, Chinese, 17
 loading, 20, 52
 using, 19
Brushes, watercolor, 23
Buds, 52–53, 57
Cactus, 115–117
Calligraphy, 33
Canvas, painting on, 123–125
Chop, placing a, 15, 18, 33, 51, 61, 78, 83, 89, 101, 117
Chrysanthemum, watercolor, 106–109, 126
Coconut tree, 35
 spontaneous-style, 72–73
Color
 blowing, 22, 62, 69, 80, 86, 96, 102–103, 106, 123
 lifting, 70, 91, 96–97, 125

manipulation, finger, 22, 56, 95–96, 106, 124
 painting, fingernail, 96
 scratching, 70
 splashing, 112, 123–124
Colors, Chinese, 15–16
 loading, 20, 52
Colors, watercolor, 21
 See also Watercolor
Composition, Chinese painting, 28–41
 arc-shaped, 36–37, 41, 55
 balance, 33, 51, 53, 61, 83, 89, 101, 105, 117
 circular, 36
 contrast in, 29, 31–32, 48, 69, 96
 focal point, 29–30, 32, 38, 41
 horizontal, 39, 41, 112
 movement in, 38–39
 objects in, grouping and organizing,
 29, 32, 34–37
 organization in, geometric, 36–37
 rectangular, 37
 S-shaped, 36
 three-line integration, 29, 34–35, 55
 triangular, 37
 vertical, 41, 113
 white space, 29, 40
Composition, watercolor, 37
Contrast, 29, 31–32, 48, 69, 96
Corn tree, 38
Depth, creating, 32, 56, 63

Detail, 11, 32, 105–106
 See also Painting, detail-style
Dirt, 122
Effects, paper, 17
 crinkled, 118, 120–121
Eye, leading the, 34–39, 55
Floral painting, Chinese, development of, 10
 See also Painting
Flowers
 background, 106
 distant, 46, 80
 half-open, 100
 painting, methods for, 12
 secondary, 102–105
 See also under specific flower
Focal point, 29–30, 32, 38, 41
Foliage, distant, 62
Frogs, 11
Glass, printing with, 112–114
Glue, as resist, 115–117
Grapes, 33, 37
 spontaneous-style, 93–94
 watercolor, 95–98
Grass, 22, 24, 51, 86, 89, 122
Happy dots, 53
Hibiscus, 38
Highlights, 13, 71, 91, 94, 97
Hollyhocks, 36
 spontaneous-style, 99–101
 watercolor, 102–105
Images, tracing, 18, 41, 44
Ink, 16
 diluting, 12
Irises, 11, 41
 detail-style, 44–47
Labellum, 66, 69, 118–120
Leaves
 background, 92
 grape, 93, 95, 97–98
 hollyhock, 100–101
 iris, 46
 negative painting, 97–98, 107
 orchid, 121
Light beams, 96
Lilies
 tiger, 30, 35
 water, 11, 13, 30, 82–87
Lily pads, 83, 85–86
Lines, 32
Lingnan School, 76, 111
Lotus, 48–51

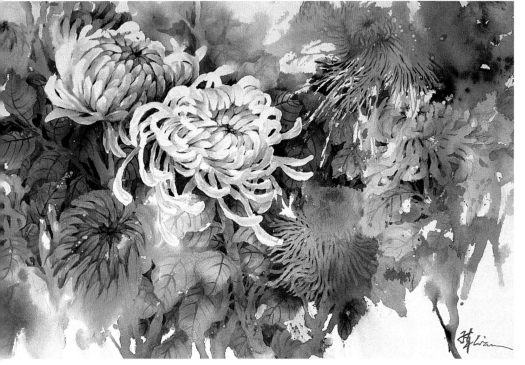

CHRYSANTHEMUM *watercolor on Arches 140-lb. (300gsm) cold-pressed watercolor paper* *14″ × 21″ (36cm × 53cm)*

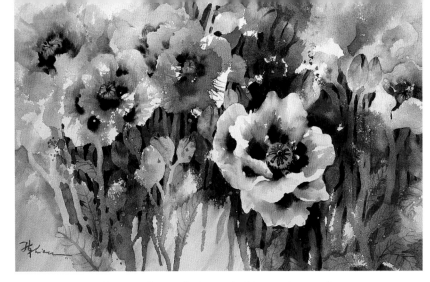

POPPIES *watercolor on Arches 140-lb. (300gsm) cold-pressed watercolor paper*
14" × 21" (36cm × 53cm)

Lotus pond, 11

Magnolia, 8, 34, 39
 spontaneous-style, 52–54
 watercolor, 55–58

Masking fluid, 21, 23–24, 55–56, 62, 68–69

Mat, felt, 15, 18, 113

Materials, Chinese, 15–20
 brushes, 15, 17, 19–20
 buying, 20
 color, 15–16
 ink, 12, 16
 mat, felt, 15, 18, 113
 paper, Shuan, 15–18
 See also Chop, placing a

Materials, watercolor, 21, 23

Morning glories, 39

Narcissus, 30

Negative painting, 25, 46–47, 57–58, 62, 70
 cactus, 116
 flowers, distant, 46
 grapes and leaves, 95–98
 poppies, 125
 rose, 79–81

Negative space, masking, 90

Night scenes, 13

Objects, essence of, capturing the, 11, 13

Orchids, 10, 37
 double, 35
 experimental, 118–122
 spontaneous-style, 66–67
 watercolor, 68–71

Painting
 Japanese, 111
 tilting a, 56, 63, 106, 112, 124
 See also Negative painting

Painting, Chinese
 Lingnan School, 76, 111
 northern versus southern, 93–94
 stretching a, 26–27
 versus western, 13, 111

Painting, detail-style, 11
 bone method in, 12
 demonstration, 44–47
 paper for, 17–18

Painting, spontaneous-style, 11, 111
 bone method in, 72
 demonstrations, 52–54, 59–61, 66–67, 72–78, 82–83, 88–89, 93–94, 99–101
 no-bone method in, 12
 paper for, 17
 water-ink, 12, 18

Painting, spontaneous/detail-style, 11
 demonstration, 48–51
 paper for, 17–18
 sketching, 18

Palette, limited, 21

Paper
 crinkling, 118, 120–121
 Shuan, 15–18
 watercolor, 21

Paper weights, 18

Paper white, saving, 21

Peonies, 12–13, 40
 spontaneous-style, 59–61
 watercolor, 62–65

Petals, 76–78
 one-stroke, 20, 52

Poppies, 123–125, 127

Printing, glass, 112–114

Rain, 69

Reflections, 13

Resist, glue, 115–117

Rice paper, crinkling, 118, 120–121
 See also Paper, Shuan

Roses
 spontaneous-style, 76–78
 watercolor, 79–81

Rule of thirds, 30

Salt, table, 69

Sepals, 53, 57

Shadows, 13
 watercolor, 63

Shui-mo hua, 12

Signature, adding a, 33, 51, 61, 89

Sketching, 18
 focal-point, 104, 107
 ink, 74
 See also Images, tracing

Snow, 69, 118

Stems, 22, 24, 46, 53

Strokes, 13
 center-brush, 19, 53
 minimizing, 66
 as shapes, 32
 side-brush, 19–20

Style. *See* Painting

Sumi-e, 12

Sunflowers, 36

Techniques. *See* Color

Texture, 19, 22, 72, 96, 102–103
 blown, 69, 96, 102–103, 123
 paper, 118, 120–121

Thorns, 78

Tiger lilies, 30, 35

Tomatoes
 spontaneous-style, 88–89
 watercolor, 90–92

Trees
 banana, 74–75
 coconut, 35, 72–73

Trumpet creeper, 38

Value, 22, 31–32
 contrast, 69, 96, 99
 gradation, 64
 variation, 32, 63

Vines, 68
 grape, 93–94, 96, 98

Water, 82, 85–86

Water lilies, 11, 13
 spontaneous-style, 82–83
 watercolor, 84–87

Watercolor
 demonstrations, 55–56, 62–65, 68–71, 79–81, 84–87, 90–92, 95–98, 102–109
 materials and techniques, 21–23
 pouring, 22–23, 55, 62–63, 68, 84–86, 106

White space, 9, 29, 40

Wisteria, 37, 112–114

Yin and yang, 31

THE BEST IN FINE ART INSTRUCTION AND INSPIRATION IS FROM NORTH LIGHT BOOKS!

Watercolor Depth & Realism

by Laurie Humble

ISBN-13: 978-1-60061-045-5, ISBN-10: 1-60061-045-5

hardcover, 128 pages, #Z1593

Learn how to take a "flat" painting and create a sense of depth using 5 different techniques to animate the composition and increase the overall depth and realism. The 5 key concepts featured include contrast, color saturation, perspective, detail and unifying washes. Step-by-step demonstrations, short exercises, close-up details, before-and-after comparisons and samples of finished work help convey and reinforce the importance of the 5 key concepts.

Exploring Textures in Watercolor

A Hands-On Approach

by Joye Moon

ISBN-13: 978-1-60061-028-8, ISBN-10: 1-60061-028-5

hardcover with concealed spiral, 144 pages, #Z1315

Exploring Textures in Watercolor offers a combination of examples, mini-demonstrations and full step-by-step demonstrations showing ways to master the concepts of value, color, negative space and texture. A full range of techniques is explored, including pouring, masking, splatter, stippling, resist, collage, scraping and more. These basic skills and techniques are then incorporated into full-length demonstrations, and bonus inspirational sidebars provide readers with ways to add texture to their lives.

Confident Color

An Artist's Guide to Harmony, Contrast and Unity

by Nita Leland

ISBN-13: 978-1-60061-012-7, ISBN-10: 1-60061-012-9

hardcover with concealed spiral, 160 pages, #Z1059

The approach to color theory in *Confident Color* makes selecting colors easy and efficient. Learn the importance of color schemes and color contrasts and how to use them effectively when painting to take your compositions to new heights. A lively illustrated color glossary provides a refresher on color basics so that you can focus on more complex theories.

These books and other fine North Light titles are available at your local fine art retailer or bookstore or from online suppliers. Also, please visit our website at www.artistsnetwork.com.